PERSPECTIVE

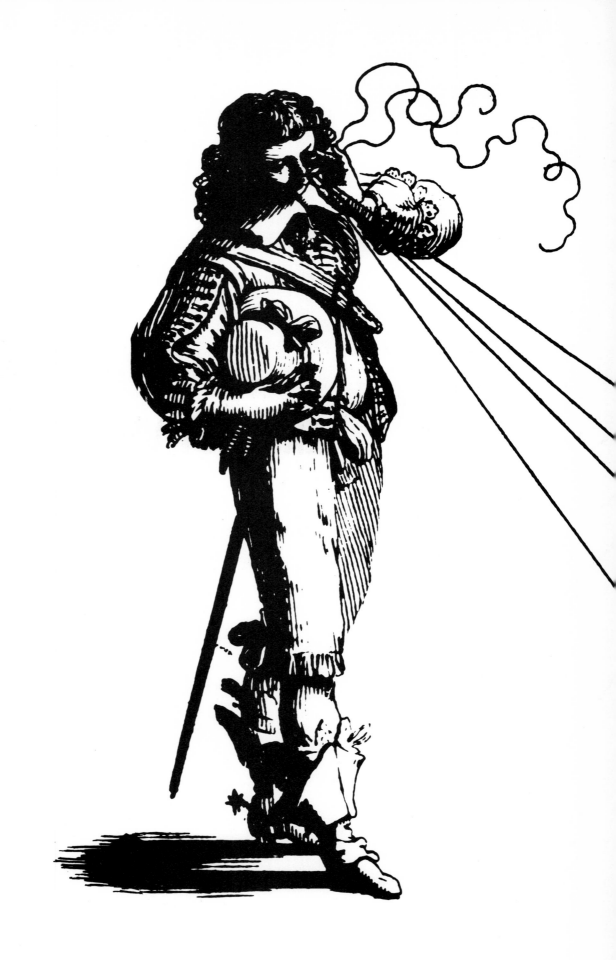

PERSPECTIVE

Introduction and Commentary by
PIERRE DESCARGUES

Translation by I. Mark Paris

HARRY N. ABRAMS, INC., PUBLISHERS, NEW YORK

EDITOR: Ellyn Childs Allison

DESIGNER: Dirk Luykx

The author and publishers wish to thank the perspectivist and
engraver Albert Flocon for his interest in this volume—and
particularly for his advice and his correction of errors.

Library of Congress Catalogue Card Number: 77-81949
ISBN: 0-8109-1454-9
ISBN: 0-8109-2075-1 pbk

CONTENTS

18TH CENTURY

19TH CENTURY

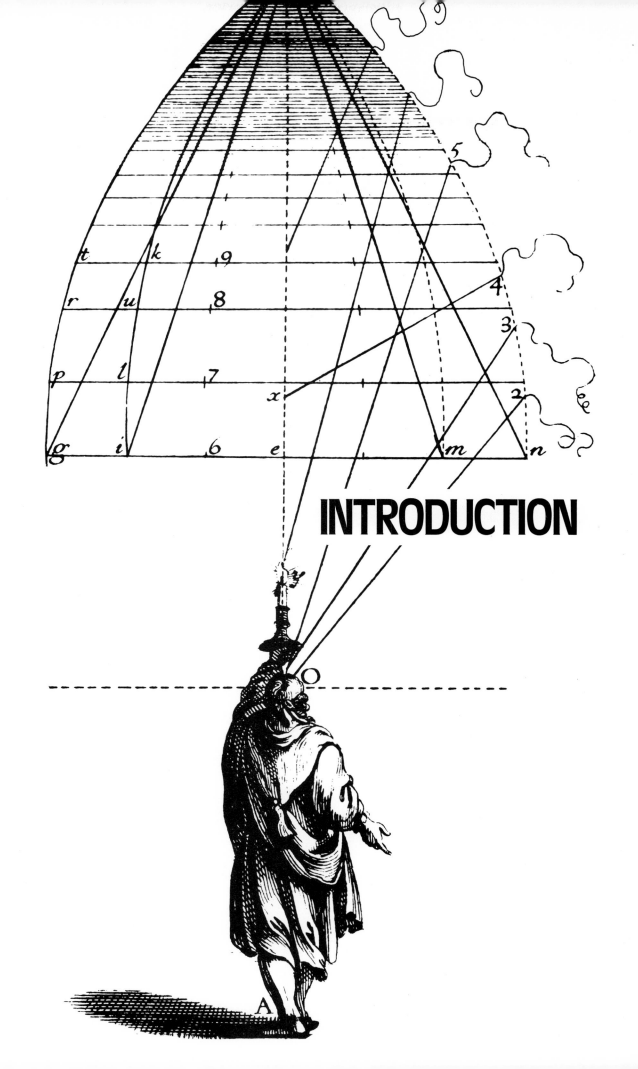

INTRODUCTION

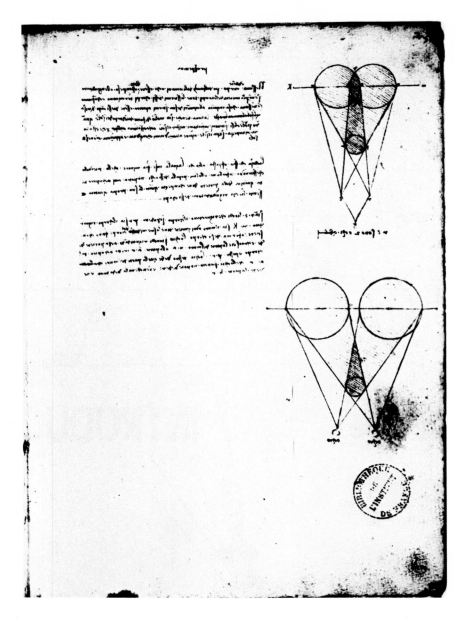

1. Leonardo da Vinci, Manuscript C, c. end of the fifteenth century.
Bibliothèque de l'Institut de France.

O che dolce cosa è questa prospettiva! —PAOLO UCCELLO

Perspective is a way of thinking about observation, a method that harnesses and organizes space. It is a fundamentally practical technique: given two dimensions, it computes the third and, conversely, permits three dimensions to be projected onto two. Because it takes angles into account and projects space onto plane surfaces, it is related to both trigonometry and cartography. Colleagues of those who use the technique include the surveyor, the builder, and the topographer, who share the task of conveying the features of a town, port, or region to people who have not seen them firsthand. At one time, the ballistics expert, the gardener, and the mason also were close associates.

Making use of perspective opens doors in several directions: it enables the observer to see not only what is, but also what was and what might be. Perspective states the facts, but it also stimulates the imagination; it shows the past and future as well as the present.

Today, perspective is no longer in the same circumstances as it was two centuries ago. In 1925, the Constructivist El Lissitzky wrote, "Perspective bounded and enclosed space, but science has since brought about a fundamental revision. The rigidity of Euclidean space has been annihilated by Lobachevski, Gauss, and Riemann." In their recently published *Premiers pas dans la perspective*, professors Quinet and Ferrero pigeonhole it precisely. "We have at our disposal three techniques for conveying the image of an object or structure: flat projection, perspective, and photography. The latter does not enable us to determine the various dimensions. Although flat projection facilitates measurement of dimensions, it requires several views. Perspective . . . unites the advantages of both techniques."

Thus, deemed outmoded by contemporary artists, who consider it incapa-

ble of participating in a modern conception of space, perspective has been relegated to the purposes of industry. Once the inspiration for ambitious thought, it is now a mere tool of the everyday world.

As we read the lengthy titles of sixteenth- and seventeenth-century treatises on perspective, we come to understand what it was that attracted and inspired their authors. If the topic under consideration was how to measure distances, they would append a technique for computing the circumference of the earth, thus bringing surveying into contact with astronomy. If it was a demonstration of how to show an inscription in perspective at various levels of a tower, they would choose as an example the ancient dictum "Know thyself." Perspective was applied according to a unique way of thinking that took in the entire universe, from the infinite to the infinitesimal. As such, it was a constituent of total knowledge.

The tools required for work in perspective—a fixed eyepiece, a glass or latticed panel, a bit of thread—were added to the panoply of the complete Renaissance humanist. They took their place next to the compass (for measuring angles); the square (for determining perpendiculars); the sextant, which led Amerigo Vespucci to the New World; and the scalpel of Ambroise Paré, who first discovered how to apply ligatures to arteries.

To these was later added the telescope, with which, on August 21, 1609, astonished Venetian authorities perched at the top of the Campanile in the Piazza San Marco were able to see the façade of the Cathedral in Padua. Prior to this, in 1525, the first map of France, by Oronce Finé, a French mathematician and astronomer (1494–1555), appeared; but even earlier, in 1505, the first treatise on perspective was published in France. All intellectual disciplines would now move in the same direction: European man had set out to conquer the world, and he enjoyed having himself portrayed with all the little machines that gave him the power to do it.

Books would provide men of skill and thought alike with the formulas for the machines, the lucid reasonings. Everyone would forge his own keys to the world, and once man discovered the laws governing objective reality, painting, drawing, and engraving would reflect and be part of the real world.

This consolidation of knowledge was a phenomenon peculiar to Europe. For instance, though the Arabs were generally more sophisticated than Europeans in scientific matters, geometry did not give rise to perspective in the arts in the Moslem world. Nor in the Far East did technical and artistic knowledge evolve at the same pace.

In any event, Europeans were fully aware that perspective contravened the basic principle of Euclidean geometry, namely, that space extends infinitely in three dimensions. While Copernicus's idea that the universe does not revolve around our planet was first being disseminated, the advocates and users of perspective were resolutely maintaining in every painting, every engraving, every bird's-eye view of a city or garden that the center of the universe is the individual looking at it. All things were reduced to signals received on the retina; all things led to man.

Perspective helped foster this illusion, of course, but it also eased the tasks to be done. People lived happily with it for a long time indeed. We in our era utilize the photographer and the radar operator in the same way that men in

earlier centuries made use of the perspectivist. For example, the aerial photographer provides information about buildings, troop movements, and atomic plants. The radar operator can instantly monitor the movement of planes, rockets, ships, and submarines. Perspective was, in its day, such a tool of knowledge as radar is today. The difference is that contemporary artists are not competing with radar technicians. From the fifteenth century on, painters took over the system that put the physical world in order, and its use as a weapon gradually decreased in importance. Initially a tool to discover truth, perspective was condemned when it became incapable of serving anything but beauty.

Over the centuries, treatises on perspective proliferated, and each one referred to its predecessors in a dialectic of refutation, correction, and elucidation that continued vigorously until the first half of the nineteenth century. From then on, works were edited with less care, ánd the quality of illustrations deteriorated. Who can say whether this decline in a technique more or less linked to Euclidean geometry reflected the birth of a non-Euclidean geometry. Did the latter "kill" the former? To be sure, startling currents of influence spring up between diverse fields of knowledge. But it is also true that, in due course, every endeavor exhausts itself, every inquiry runs dry, and that an idea believed alive may actually be dead, while an apparently worn-out thought may still be productive.

The objective of this book is to isolate certain persistent tendencies in the history of perspective, not to provide an exhaustive survey of treatises on the subject. We aim instead to trace the evolution of the genre and, when the high quality of the illustrations calls for it, to make detailed examination of certain works.

People today believe they have finally completed their rounds of those museums of the imagination painting and sculpture. But museums still unopened have yet to expose the public to drawings contained in books. These are didactic pictures that teach by combining elementary information with the most complex artistic creation, all the more unusual in that they reveal an interior mechanism at work, interacting with a sophisticated world view. It is difficult to decide which is most astonishing: impressions created out of extended threads converging in a knot, views pulled into wild distortion across a curved grid, pictures that materialize before our disbelieving eyes, or everyday objects reduced to their geometric skeletons. We see boxes with lids and drawers in place of houses, cylinders for staircases, swiveling parallelograms for windows, polyhedrons for the manicured boxwood trees of avenues and the ancient ruins of our culture. And then, we see ourselves standing, sitting, perched atop columns, reflected in water, emerging from the dark by candlelight or by the rays of the morning, noonday, or evening sun. There we stand, encased in geometry, wearing togas like Roman senators or looking like musketeers in plumed hats, swords sticking out from our Louis Treize attire. There we lie, naked on a dissection table, living contradictions of a computed universe. (Although the contradiction was denied when anatomy books took their place on the library shelf, these compendiums still differentiated between the articulated joints of the human body and the functioning of the mind, whose mathematical framework remained securely hidden from view.)

The charm of these prints derives from the coexistence of two systems. One might hesitate to discuss them too readily in terms of surrealism, but such caution

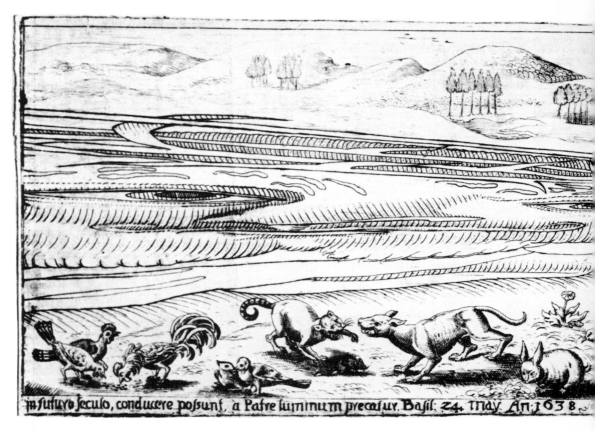

in futuro feculo, conducere possunt, a Patre luminum precatur. Basil: 24. may An: 1638

2. Johann Heinrich Glaser, engraving, 1638. At right, in normal perspective,
The Fall from Grace; at left, in anamorphic perspective (correctly viewed diagonally
from the extreme right edge of the picture), *Christ with the Crown of Thorns*.

12

is ill founded. After all, extraordinary linkages are the very stuff of surrealism: "Le scarabée, beau comme le tremblement des mains dans l'alcoolisme, disparaissait à l'horizon" (The beetle, beautiful as the trembling of hands in alcoholism, disappeared into the horizon).* So too, the lesson taught by perspective— beautiful as ... well, the individual must formulate his own reaction to perspective—illuminating if one abides by its rules, obfuscating if one refuses to subscribe to a world measured according to human scale. It is the movement between the two that is pleasurable, between a methodical technique that cuts into the real world like a scalpel and the real world that encompasses it, closing in like the lips of a scar.

The idea of perspective was put into practice before it was written about, a fact borne out by the work of Giotto. Subsequently, the Limbourg brothers, Jean Fouquet, and Ambrogio and Pietro Lorenzetti contributed to the gradual systematization of the technique. The desire to state the facts definitively was manifested first in Italy, by three men—Filippo Brunelleschi, Leonbattista Alberti, and Piero della Francesca. Brunelleschi contrived two brilliant practical demonstrations of the method (c.1420), but Alberti and Piero drafted treatises on the subject, thereby elevating technical procedure to the more refined level of humanist writing.

The first printed volume on perspective in art was a Latin text by Jean

*Lautréamont, *Les Chants de Maldoror*, V.

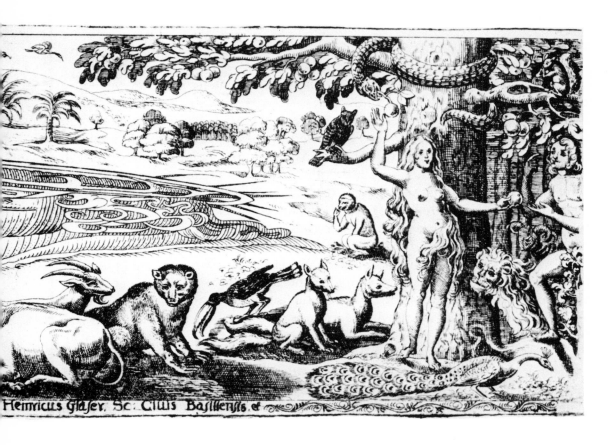

Heinricus Glaser, Sc. Ciuis Basiliensis, et

Pélerin (pseudonym Viator), published in 1505 in the free city of Toul. Born sometime prior to 1445, he was secretary to Louis XI until, around 1500, he became a canon at Toul, where he died in 1524. A tract on Ptolemy and a translation of the Book of Job from Hebrew into French made a name for him. His *De artificiali perspectiva* also met with success: it was published in Latin in Toul in 1509, again in Toul in 1521, and translated into German in Nuremberg in 1509. In 1626, an enthusiast who deemed Viator's work still valid refashioned it into a modernized version with plates reduced in size, additional illustrations, and contiguous Latin and French texts. The flavor of the latter is revealed in the following quote: "La pyramide droite sert pour le plan et le pavé; la pyramide pendante ou renversée sert à figurer le plancher ou le toit; la couchée ou latérale sert pour les côtés et celle des tiers points sert à donner le raccourcissement et pour des bâtiments vus par angle, la pyramide double, la diffuse ou cornue, doit servir" (The right [-angled] pyramid will serve as the ground level and pavement; the hanging or inverted pyramid may represent either the floor or the roof; the slanted or lateral ones serve as walls, while the tierce-points are used to foreshorten; and for buildings viewed obliquely, the double—the so-called horned or diffuse—pyramid may be employed).

 This series of editions contained nearly the entire repertory of forms that would appear in similar collections for centuries to come, namely, the polyhedrons and buildings of antiquity—pyramids, triumphal arches, columned galleries. The characters that people Viator's architectural dramas were drawn from

his own time, just as, in the next century, Abraham Bosse would fill his engravings with figures in contemporary costume.

However, an allusion to Pope Julius II—his initials are engraved on a thoroughly Italian loggia in one of the plates—transports us to a world obviously far removed from that of Viator. Patron of Bramante, Michelangelo, and Raphael, Julius would no doubt have been surprised at the provincialism of certain of Viator's illustrations: jumbled together with buildings inspired by the intrusive influences of Italy and the ancient world are Viator's perspective drawings of fifteenth-century country dwellings, the halls of justice in Paris, the Sainte-Chapelle, and the Cathedral of Notre-Dame, construction plans for fortified bridges, and a wagon presented in three views, enabling the reader to observe it from all angles and to build others like it.

Thus, the treatise on perspective delineated its author's sphere of interest from the very start. Equally at home in the bedroom as in the more august surroundings of antiquity, Gothic art, or the Renaissance, it cut across all styles and served all branches of knowledge, from architecture to coach-building. It was practical. It was universal.

The reader will notice that Viator's drawings are free of the construction guidelines that clutter the sketches of later authors, who wanted to leave no room for doubt in the mind of the student. His diagrams are limited to a few geometric planes viewed in perspective, a few grids used to indicate and explain vanishing lines. Viator was more concerned with showing how the technique worked than with tryingto prove its validity. The same is true of the illustrations in treatises published shortly thereafter: books bearing the stamp of the new method were released well before it had been fully accepted. Thus, Viator, not an artist but rather an inquisitive observer of everything geometry had to offer, found himself rubbing elbows with masters of artistic creation—the architects Brunelleschi and Alberti and the painter Piero della Francesca—in a common impulse to organize space. Indeed, this would always be the case: artists and architects would not be the only ones to make contributions to the genre. Thus, in the company of the engineer, geometer, optician, and soldier, we find Canon Pélerin, first in a long line of clergymen devoted to serving the Lord through reason.

As to how such books were utilized, it appears that here, too, a pattern was set from the very first. Generally speaking, painters did not take specimen drawings as their models, although an artist might occasionally appropriate an architectural detail as a point of reference. Rarely was a composition in perspective copied directly; the structure always bore the stamp of the artist's sensibility and personal vision.

So successful were the treatises that they soon were published simultaneously in several languages or translated soon after publication. As one followed another, they began to show mutual influences. For example, Albrecht Dürer's illustration of an artist constructing a painting of a lute by using a system of strings and a screen to achieve the correct perspective view was recopied a good many times. Although all these beautiful plates remained in circulation for quite a while, they were confined within the closed world of treatises on perspective, self-energized and self-contained. Art, which had a life of its own, nourished the treatises with its discoveries; but perspective engravings did not, in turn, alter the course of artistic evolution.

3. M.C. Escher,
study for a lithograph,
Staircase, 1951. Ink.
1968 catalogue, no. 99b.

Born in Italy, first published in France, the perspective treatise soon found a home in Germany. We have already mentioned that a German version of Viator's book appeared in 1509 in Nuremberg, and there, too, Johannes Werner's *Libellus super vigintiduobus elementis conicis* was published in 1522. They paved the way for the works of the Nuremberg master Dürer, which began to be published in 1525. Dürer had already journeyed to Italy to seek out scholars versed in the secrets of "divine Proportion." He found what he was looking for, and his writings took stock of the new science. When they were published, the Italians gave them a hearty reception but stubbornly deplored the style of the author.

In 1584, Giovanni Paolo Lomazzo wrote that "Alberto Durero" had done more with perspective than anyone else but that his paintings were barbaric. Another admirer, the Frenchman Paul Fréart de Chantelou, criticized Dürer in 1662 for painting "Gothic nonsense." Clearly, Italy was uniquely and peculiarly destined to nourish the miraculous rebirth of antiquity. Beyond her borders, it was impossible to be anything but barbaric. Granted, an outsider might devise a method for creating perspective but he was not steeped in the beauty of the new order that was replacing the old. Foreigners might work out a system as a basis for arriving at truth but they could not hope to enter the realm of the ideal that Italy felt was hers alone. Thus, initially a practical and universal technique as utilized

by Viator, perspective soon became associated with a particular style based on the urban space, a concept itself dependent on a certain climate and social setting.

Italian perspectivists invented a new brand of theater-space based on lines extending from inclined planes toward artificial vanishing points. No longer did the actor merely stand before a painted backdrop: now he was actively integrated into the scenery behind him. In 1545, Sebastiano Serlio celebrated the theatrical transformation of the Italian city into a recreation area: in the *prospettiva urbana,* a stage set showing a city's most important monuments aligned on the two diagonals of the perspective, urban space was arranged to serve Drama. In late sixteenth-century Vicenza, Andrea Palladio designed a theater proscenium with a plaza and seven streets leading out from the back of the stage at an extremely oblique angle to increase the perspective depth. Intended as a framework for every conceivable kind of play, from comedy to tragedy, the theater drew audiences that knew perfectly well what attracted them: perspective allowed them to watch themselves in their own city. As a result, the status of painting as the supreme portrayer of man and his surroundings was threatened. The theater—its enclosed space soon enhanced by mechanical wonders and optical illusions—was the masterpiece of perspective, the culmination of the Renaissance endeavor to build everything around man, to show that his limbs were the yardsticks of the universe. Erect, inscribed in a circle like the sacred center of a mandorla, man became the contemplated being par excellence.

For a brief period, painters, stage designers, and architects all created the same kind of spatial environment according to the same laws of composition, giving rise to a culture whose hold on the world is as powerful as ever. Enthralled tourists are still drawn to Florence, Siena, and Venice, not only by their architectural beauty, but by a certain outlook and art of living. Perspective was a life-style, a civilization.

Foreigners could only catch glimpses of this world. As Italy set about living life in perspective, Germany was plying more abstract waters, producing perspective studies of geometric forms (Lorenz Stoer, 1567; Wentzel Jamitzer, 1568) and letters of the alphabet (Hans Lencker, 1571). The information in these treatises was applied to marquetry, precious objects, and a conception of typography that infused the Germanic decorative and graphic tradition with new vigor. Perspective, which, in principle, should have blazed the trail to an objective world view, was—in Germany, at least—pressed into the service of specialized pursuits. The Germans explored particular fields of learning, whereas the Italians harked back to their origins in a quest for universality. Northern Europe preferred to follow the path of geometry; southern Europe, that of nature; but both marched under the banner of perspective.

Soon perspective grew self-critical, enriching itself in the process. Its rules presupposed that the observer put himself in the place of the perspective artist: that is, it was assumed a work could be correctly viewed only if the observer positioned himself at the exact spot occupied by the artist at the moment of creation. No picture, however, comes equipped with viewing instructions, so artists hit upon the idea of slipping in, like so much contraband, a second space, a second point of reference; in other words, annihilating pictorial logic by shattering the spatial status quo, introducing an odd object or scene that rebelliously disrupted the organization of the whole. (This is reminiscent of the phenomenon of

dual vision, alluded to by Leonardo da Vinci in his *Trattato della pittura,* where he suggested that the artist stimulate his imagination by looking for the shapes of faces, figures, and landscapes in stained and moldy walls.) In this manner, perspective, an elucidator of reality, set about contradicting itself. One of the best-known examples of anamorphosis, or distorted perspective, used in such a way is Hans Holbein's double portrait *The Ambassadors* (1533), in which an unrecognizable object, when viewed from the proper angle, far to the right of the correct position for viewing the picture as a whole, suddenly is seen to be a human skull.

The possibilities of anamorphic design began to intrigue a number of artists: the works of Erhard Schön, a follower of Dürer, are filled with these fascinating perspective games. Thirty years later, the technique made a less grotesque appearance in a treatise written by Daniele Barbaro (Venice, 1568). Anamorphosis made it possible to reveal and conceal an image simultaneously, and only the initiated could unlock the secret. Other investigations followed the same path. In 1638, Jean-François Nicéron discussed an optical device whose faceted lens, if manipulated, allowed the observer to view "a portrait of His Most Christian Majesty in French garb" where others would see a picture showing "fifteen Ottomans in Turkish garb" (his dioptric picture is now in Florence).

By the middle of the sixteenth century, the treatise on perspective had secured its domain and attained its fullest expression. Even though its repertory of images was not complete, its potential had nevertheless been fully tapped.

Il Paradosso, author of a work illustrating the technique of perspective for the untrained (*Paradossi,* 1672), sensed that Barbaro had marked the final stage of a cycle: "Daniele Barbaro," he wrote, "derived his ideas from Giovanni Zamberto, who, in turn, derived his from Piero della Francesca. He, in turn, was the teacher of Baldassare da Siena, who was the teacher of Serlio." Everything, therefore, went back to the same roots.

Perspective came full circle, but continued to generate texts. The ones that appeared in France bear witness to the fact that the primacy of Jean Pélerin was largely disregarded, reissues of his work notwithstanding. People turned instead to Italy for the rules. The treatise written by Jean Cousin the Elder (creator of that mannerist masterpiece of the School of Fontainebleau, *Eva Prima Pandora*) was a veritable repository of everything the royal court of France was busy incorporating into its châteaux, just at the time when Joachim du Bellay was returning from Italy, the *Antiquités de Rome* tucked under his arm. The French were trying to adapt to a way of thinking, a way of life. Cousin took the grotesques of antiquity, the joyously interlacing vines, and set them in a framework of calculations destined to organize not only residences and staircases, but also the regular geometric bodies that form the basis of all construction. Moreover, his was the first treatise in French to elaborate on the various architectural orders passed down from Greece and Rome. Henceforth, Doric, Ionic, and Corinthian columns were part of the cultural baggage of every artist.

Sixteen years later, in a treatise presaged by a published series of collected drawings of triumphal arches and other ancient monuments, Jacques Androuet Du Cerceau—who had also made engravings of French mannerist paintings— exploited the traditional perspective repertory (theatrical motifs, the spiral staircase, and so forth). He did so, however, in the light of a wholly new artistic vision, for the neoclassical age was beginning. The stern rigor of the right angle sounded

the death knell of fanciful design. For the architect in particular, perspective helped show buildings as no two-dimensional plan could, and in the same year, Du Cerceau brought out *Les plus excellents bâtiments de France,* whose plates bear a close resemblance to those in his *Leçons de perspective.* In the dedication to Catherine de Médicis, the author assures the queen that a knowledge of perspective will produce works of art embodying "intelligence and pleasure in fullest measure."

Du Cerceau added that his lessons were the distillation, the essence, of everything hitherto published on the subject. He apparently considered perspective an unproblematic business, a technique easily mastered. In Italy, however, violent controversy was sweeping across the artistic horizon. In 1569, the architect and painter Pellegrino Tibaldi found himself denounced before the church council of Milan Cathedral by a Milanese architect, Martino Bassi, who took exception to a certain bas-relief he deemed more profane than sacred, and after discussing the matter, the council pronounced the plaintiff's suit null and void. A record of the proceedings was published in 1572 by Bassi, and it reveals that the dispute in fact was about perspective. According to Bassi, the crux of the matter was determining if there could be one horizon line or two. To refute Tibaldi, who had used two in his bas-relief, Bassi sought the opinion of his most celebrated contemporaries. Palladio advised, "The horizon line must be placed in the middle"; Vignola replied, "I would put the horizon line higher"; Vasari also voted against the idea of two horizon lines.

Now, if perspective was a science, how do we explain the fact that these opinions, offered by the greatest specialists of the day, are so lacking in precision? Was perspective a science after all?

Over the centuries, authors of perspective treatises felt obliged to exhort those artists who, in their view, were not trying hard enough to understand. Antonio Palomino de Castro y Velasco lamented that talking to artists about theory was like speaking to them in Arabic. Brook Taylor condemned all treatises published prior to his on the grounds that they emphasized technique, through examples, at the expense of theory. Bernard Lamy contended that a mathematician who could neither paint nor sketch would nevertheless be able to produce a picture.

And they met significant resistance. In 1800, the painter Joseph Vernet explained kindly to Pierre-Henri de Valenciennes that, even after years of study, Valenciennes knew nothing: on the contrary, he had everything to learn, including perspective, but this time he should learn it from an artist. Later in the century, the mathematician and teacher of perspective Joseph-Alphonse Adhémar felt obliged to defend his point of view from attack by the critic of the *Journal des Débats,* Etienne Delécluze, who found scientifically constructed perspective "antipictorial." "I have attempted to reunite in my students the artist and the geometer; M. Delécluze has sought to divorce them." We are a long way indeed from Paolo Uccello's delighted exclamation, "O che dolce cosa è questa prospettiva!"

In fact, those who practiced perspective soon split into opposing camps: the geometers wanted to concentrate on theory, the artists wanted to create pictures. The first group insisted that everything be done in accordance with a logical series of propositions; the artists now and then considered them a handicap. Painters knew that their work need not submit to the strict laws of geometry

in order to be coherent: for them, experience and creativity's own logic sufficed. They knew how to avoid the mistakes that fill the frontispiece of John Kirby's treatise on the application of Brook Taylor's perspective theories (see Plate 141). This clever engraving by William Hogarth is accompanied by the admonition "Whoever makes a design without the knowledge of Perspective, will be liable to such Absurdities as are shown in this Frontispiece." Hogarth's didactic blunders, however, are glaring ones indeed; moreover, the author who greets his reader as an ignoramus can hardly hope to make him understand the complex method elaborated in the pages that follow.

Geometry in itself is an objective pursuit, but in the context of experience, it inevitably becomes subjective. Whether its contradictory aspects could coexist in art was therefore a question.

In seventeenth-century France, the question precipitated an artistic Thirty Years' War. It was a debate between Truth and Falsehood; a dispute between clergymen, mathematicians, and artists; a melee in which Charles Lebrun became only indirectly involved and from which Poussin kept a safe distance. None of the great neoclassical masters, in fact, became entangled in the quarrel, but the theoreticians took clearly opposing stands. "Perspective is so vital that one may go so far as to call it the very essence of painting. Even so, this aspect cannot hold a place comparable to others the painter is required to know," said André Félibien in 1666. "Painting, though grounded in geometry, creates a double image of what it represents. One needs two kinds of vision in order to enjoy the beauty of paintings fully; and the mind's eye is their first and foremost judge," Paul Fréart de Chantelou remarked in 1662. The heart of the matter was determining the degree of reality one could achieve. Indeed, the battle was fought in the name of reality to find out which technique—rigorous geometry or perspective tempered by the painter's eye—came closest to it.

The era put its faith in reason: nothing would escape its inquisitive eye. Every undertaking had to have a method. With the correct laws, man would be master over all. The artist could not be allowed to think that he might dodge the rules by dissociating his work from that of the mathematician, the physicist, and the geometer. His destiny was to remain bound to theirs. In his preface to *Iphigénie*, Racine remarked, "I have noted with pleasure that good sense and reason are the same in all ages—witness the effect produced on French theater by my imitation of Homer and Euripides. The tastes of the Parisian have turned out to be consistent with those of the Athenian." In 1663, Paul Fréart de Chantelou, in his preface to a translation of Euclid's *Perspective*, put it more succinctly: "We hope soon to witness [in France] a rebirth of the same things that made Greece so admirable." France in the seventeenth century was striving to perfect knowledge, to rediscover antiquity's ideal of a perfect balance of all factors. The imperatives of the day were to incorporate passion into order, to find a form for everything, and to organize space according to the dictates of reason (a sentiment perfectly expressed in Plate 98, a print from Grégoire Huret's *Optique de portraiture*, in which the royal throne is shown in the center of the composition, at the focal point of the perspective structure).

In the year preceding the appearance of René Descartes' *Discours de la méthode*, the geometer Gérard Desargues, father of modern projective geometry, published his *Méthode universelle de mettre en perspective les objets donnés réellement ou*

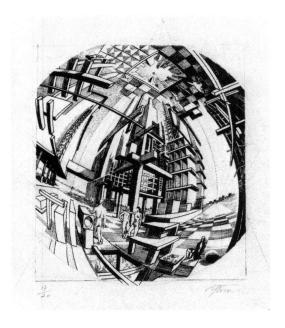

4. Albert Flocon, engraving in curvilinear perspective, 1968.

en devis (1636). The ideas of Desargues were made relevant to the concerns of artists by Abraham Bosse, a specialist in copperplate engraving. Desargues, in fact, had invented a novel, truly precise method of projecting three-dimensional objects in their real spatial positions on a two-dimensional plan—something artists had previously been able to do only by working through a cumbersome series of steps; as a result, they had tended to rely on an abbreviated, less accurate construction. The key word here is *precise:* the abbreviated construction was visually convincing, but the new one was absolutely mathematically precise. Bosse and Desargues in emphasizing the accuracy of the new method became pressing and intransigent and irritated many artists who maintained the usefulness of established conventions of painting and the supremacy of the painter's ''eye'' and sensibility.

"Prior to M. Desargues," Bosse wrote, "we in France were without a treatise on perspective that spoke about the strengths and weaknesses of portraiture." This thrust was parried, in turn, by Jean Dubreuil, whose *La Perspective pratique* (1642–49) bore the stamp not only of Desargues (as well as his contemporary Jean-François Nicéron) but of such primary sources as Viator, Dürer, and Cousin. "However excellent a painter may be," he writes, "he must follow all these rules or end up appealing only to the ignorant. But even a mediocre painter who has mastered them shall be marveled at by all." Dubreuil's volume styled itself a vade mecum and indeed remain so for many years; its influence was felt as late as the mid-nineteenth century in such works as Giacomo Fontana's *Prospettiva dimonstrata* of 1851. Parodies began to appear, with such titles as *Avis charitables sur les diverses oeuvres et feuilles volantes du sieur Girard Desargues* (Benevolent warnings concerning the sundry looseleafed works of Girard Desargues, Esq.). Signs were posted at Parisian intersections denouncing "incredible blunders" and "monstrous falsehoods." An associate was condemned for intending to use Desargues' method as the basis for building his masterpiece.

The storm reached the doors of the Académie Royale, where, deploying his

troops, Lebrun, chief painter to the king, showed no preference to Desargues, Bosse, or Dubreuil, all of whom were strangers to the club. However, he did cast a favorable glance toward the engraver Jacques Le Bicheur, who dedicated his *Traité de perspective*, which advocated the abbreviated perspective method, to Lebrun: "This little work is more yours than mine. It is only fitting that it return to its source." To which Abraham Bosse replied in the form of a letter addressed "to the members of the Academy, containing proof of the duplications, disfigurements, and falsifications of M. Desargues' style of perspective as plagiarized by Le Bicheur."

In 1661, the following year, a friar, Claude Bourgoing, had *La Perspective affranchie* published in reply to a defiant offer by Desargues of a thousand francs to anyone who could devise a mode of perspective superior to his. Finally, in 1670, Grégoire Huret, engraver of the works of Rubens, Simon Vouet, and Sébastien Bourdon, refuted both Desargues and Bosse in the second half of his *Optique de portraiture et peinture*. The Academy, for its part, had decided to expel Bosse in 1661. The war had dragged on for over thirty years.

The French neoclassicists followed in the footsteps of the Italians by drawing on scenes of everyday activity to illustrate principles of geometry. It seems surprising to us that a picture showing three overturned Louis Treize armchairs should be offered as a model for students; yet, this was precisely what the engraver Abraham Bosse did. His stylus recorded the streets, workshops, and poorhouses of Paris as well as the usual ancient monuments. For him, the daily life of Paris carried the same cultural weight as the triumphal arches of Rome.

Thus, there emerged once again a society able to effect a complete accord between its mode of existence and what was felt to be its model from the past. Like its Italian predecessors, the French city became a theater built in perspective where heroes from antiquity, dressed in the attire of the royal court, could act out their dramas. But aside from the revival of a system of thought, to what extent were invisible bonds really tied anew, fresh roots planted, cultural families reunited? The scope of this phenomenon surely extended beyond such events as the joyful presentation of a translation of Euclid's *Perspective* to Louis XIV, miraculously rediscovered just in time to justify his concept of the State scientifically. The French were living in a state of grace.

Not all countries, however, basked in this mirage. To be sure, every royal court in Europe had rules for assigning its members to positions, according to rank, in the social space newly put in perspective. Even though these manuals of Christian courtesy dictated everyone's conduct, it was often possible to avoid the excessive rigor that characterized the French, such as the rules expounded in a typical manual, *Les Règles de la bienséance et de la civilité chrétienne*, by J.B. de la Salle, first published in 1713 and reprinted up until at least 1825. Consider the Frisian artist Jan Vredeman de Vries (born 1527), whose *Perspective*—first published in 1604, believed also to have been the year of his death—was easily the equal of Jean Dubreuil's volume in terms of scope and success. He carried on a career as painter, engraver, and architect in Gdansk, Prague, and the Low Countries and published works on gardens, architectural styles, and decorative motifs. Both the theoretical and the practical content of *Perspective*, published in Leyden with plates engraved by Hondius, were addressed—and this is his own enumeration—to painters, engravers, sculptors, ironworkers, architects, masons, cabinetmakers, and car-

penters. There was no place for such caprices as anamorphic design in this self-proclaimed embodiment of sober efficiency. By stressing the essentials of building, by laying bare the structural framework, this treatise went right to the heart of architecture.

Albrecht Dürer was the theorist who inspired Vredeman, some of whose ideas clearly reflect engravings by the German master. Dürer's vision had been a passionate one; but for Vredeman, technique was all. Nothing could escape it, from the vaults and domes of ancient buildings to Gothic structures and mannerist gardens. It enabled him to construct aquatic galleries such as the Venetians had never dared attempt, and it exploited every one of the five architectural orders—Doric, Ionic, Corinthian, Tuscan, and Composite.

Vredeman traveled widely and, in the process, showered his contemporaries with information. In his view, perspective was the key to everything: as such, he felt, like Viator before him, that it was the handmaiden to all endeavors. Styles might come and go, but perspective would remain.

After his death, *Perspective* came to the attention of Samuel Marolois, who had access to an astute Dutch publisher who could assure wide circulation by bringing out editions in several languages. Ten years after Vredeman's death, Marolois added a preface to the illustrations in *Perspective.* Twenty years later, he surrounded them with studies on geometry and fortifications, thereby setting in motion an endless dialectic of correction. Vredeman's treatise fully deserved the praise it had received, but it seemed as though the author had overlooked a number of things: Marolois corrected certain "errors," and two or three plates were added, not only to point out the author's mistakes but to correct them and show how they could be avoided. In a subsequent edition, a mathematician, Albert Girard, took a turn at rereading, correcting, and supplementing. Since the aim was to be as comprehensive as possible, the reader soon found grouped together such items of interest as the theory of anamorphosis, a picture of a medieval castle atop a rock in the middle of a lake, and views of such "essential" buildings as the Coliseum, the Baths of Diocletian, the Baths of Antoninus, and the Temple of Diana. Gone was the organization based on solid documentation so vital to Vredeman, who planned his book with the efficiency of a shipbuilder.

Perspective thus became diluted in a sea of generalized data that could no longer serve as a cultural locus. Be that as it may, a hundred years after Dürer, perspective was still a science in the making whose elements and concerns remained curiously unchanged.

Eighteenth-century treatises on perspective derived their impetus from preceding centuries. There were new declarations of war, new and unremitting debates over the relationship between art and mathematics. The old tug-of-war continued. In the meantime, studies in geometry written by Brook Taylor—he was to artists of his day what Desargues had been to Bosse—spread over the whole of Europe, appearing in Italy as well as in France and the Netherlands.

In the *Opticks* (1704), Newton devotes special attention to light and color. Perhaps there are certain visual refinements in the rendering of landscape on the part of such eighteenth-century artists as Guardi, Bellotto, and Boucher that betray new influences from the world of science (the "definitive" styles of Poussin, Claude Lorrain, and Gaspard Dughet notwithstanding). Yet, as late as 1774

Thomas Malton recommended using the same paraphernalia of paper and thread as had authors of perspective treatises a century earlier. The apparatus was still the only way of making even the least rational of painters understand that vision was a rational business.

In 1725, the architect Jean Courtonne wrote that perspective had all but vanished from the sacred hierarchy of the fine arts. Bernard Lamy remarked in 1701 that—prior to *his* book, of course—the only useful purpose perspective served was to create stage scenery. But these were premature condemnations. As it turned out, perspective found its most fertile breeding ground in the eighteenth century. It reigned supreme everywhere. So skillfully was it designed, one could not tell whether church decoration was painted on or actually built; in theaters, such designers as Ferdinando Galli da Bibiena constructed imposing scenery that made the actors appear small by playing tricks on the eye. Perspective also reigned supreme in the streets through clever arrangements of buildings and monuments: in fact, to a greater degree than the era of palaces and classical buildings, the eighteenth century was the age of the city. No longer did cities attempt to duplicate the splendors of antiquity, whose monuments were now depicted as ruins. Every city in Europe became a theater, and society extended its ceremonies far into the suburbs. It was believed that, when set in perspective, space could be experienced by an entire population. Townspeople began to collect panoramic views of all the capitals of Europe. In response to this demand, a new generation of landscape painters arose, the most celebrated of whom, Canaletto, began his career in stage design.

Giovanni Francesco Costa, a Venetian architect and painter, instructed the readers of his *Elementi di prospettiva* (1747) in perspective, using figures that seem to have stepped out of the works of Francesco Guardi and Pietro Longhi. In his collection *Delizie del Fiume Brenta* (*Delights of the River Brenta*)—on whose banks, incidentally, Palladio had built his villas—there is an engraving that depicts a painter stationed beneath his landscape-artist's parasol, leaning over a *camera ottica*, a mechanical device for creating correct perspective views.

Reality could now be projected two-dimensionally on a rough glass plate inserted in the *camera*, an optical chamber whose arrangement of mirrors and lenses prepared the way for the modern telescope and wide-angle lens. All that remained to be done was to fix the image permanently. Photography, in a sense, is merely an extension of perspectivist technique as applied to painting.

Successful though they were, the artists who devoted their talents, often assisted by the optical chamber, to rendering cityscapes and landscapes with meticulous accuracy, did not hold a high place in the official art hierarchy: Canaletto, for example, was admitted to the Venetian academy only after long delay. Yet today, we view the era in the framework of his paintings; and Bernardo Bellotto's city views were used to reconstruct Warsaw.

In fact, perspective consolidated its power during the eighteenth century. People literally lived in perspective. Viewpoints determined the layout of entire cities: by allowing for mass movements of people, urban planners created spaces that allowed for the collection of disaffected mobs that would eventually topple political regimes.

Andrea Pozzo's treatise (1693–1700) remained influential throughout the century, slowly replacing even Dubreuil's work. But the most beautiful—and

most comprehensive—volume of all was *Lucidum prospectivae speculum* (1727), published by the Lübeck artist Paul Heinecken. Nothing is omitted: polyhedrons, reflections in water, the effect of candlelight by day as well as night, staircases, the most daring vaults, and undreamed of flights of fancy as expressed in pulpits of Baroque churches. Moreover, Heinecken manifests a thorough knowledge of the pitfalls of perspective.

In Thomas Malton's book (1774), we note a revival of Jean Pélerin Viator's ideas and of perspective as applied to mechanical drawing. Just as the canon of Toul had sketched a cart, so Malton, with London buildings as his background, depicted carriages, machines, and pieces of furniture. His work foreshadowed the increased use of perspective in industrial art.

The old debate continued into the nineteenth century. Brücke and Helmholtz stressed the unalterable demands of science ("perspective belongs to the geometers"), while Pierre-Henri de Valenciennes announced in the year VIII of the revolutionary calendar (1800) that "geometers know nothing about painting."

Valenciennes was the first author of a perspective treatise to take note of a new invention that was being developed by artists interested in large-scale landscapes—the panorama. This optical refinement, which offered a 360-degree view of reality, was invented by a Scottish painter, Robert Barker. In 1792, Londoners flocked to admire the first "panorama of the English fleet anchored between Portsmouth and the Isle of Wight." The same technique was used in 1798 to show Parisians "the evacuation of Toulon by the English." Valenciennes describes "this ingenious way to present an entire country scene or the whole of a city without in any way transgressing the laws of perspective," and adds that "this new approach to painting could prove to be a valuable contribution to knowledge." Just as the theater, as envisioned by Serlio, was felt to outshine paintings and frescoes, so now painting, unable to give the observer a "rear view," was threatened by the panorama. Once again, perspective had given rise to a technique destined to make painting obsolete. Louis Daguerre went a step further by adjusting painted fabric to transparent screens, thereby producing what was called the diorama. He helped regiment vision by mobilizing teams of perspectivists who would, it seemed, finally put an end to the confused thinking of landscapists. The venture was supposed to be the supreme effort of scientific thought. Unfortunately, the panoramas and dioramas fell victim to fire (they are still being built, but only in the Soviet Union). We today have no working examples of these circuses of total vision, though museums still display the often mediocre spatial compositions of landscape artists.

It was the public show that afforded perspective its principal vehicle during the nineteenth century. Treatises written for painters declined in number, and it is significant that the plates no longer show contemporary figures but Romans clad in togas, moving about villas dotted with statues. In 1851, Giacomo Fontana published a collection of drawings that reflect all styles and all epochs: Gothic, Turkish, Chinese, Byzantine, Persian, Egyptian—everything was put in perspective. No longer concerned with the present, perspective set about restoring the past. It had always been within its power to serve the imaginary as well as the real, but the nineteenth century's idea of the past gradually lost all vitality: neoclassicism gave way to academism. While perspective in art was falling victim to the

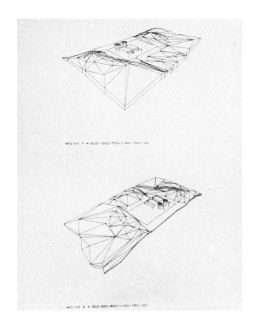

5. Claude Parent, computer-drawn sketch used to site a nuclear generating plant. Electricité de France.

Impressionists' quest for pure visual sensation, other specialists took over the project of objective spatial representation. From now on, the field belonged to the scientists, who were to perfect photography, motion pictures, and such subsequent refinements as Cinerama. The schism between art and science was complete.

Remarkable things are still being accomplished today, of course. Albert Flocon, with the help of André Barre, has invented a kind of curvilinear perspective that yields a total visual field by incorporating into a single view everything in back of the artist (see Plate 4). However, treatises on perspective are, generally speaking, few in number; they offer little interest to anyone other than architects and industrial draftsmen. Even in these areas, perspectivists—no better armed today than in the fifteenth century—find themselves competing with the computer, which can instantaneously supply images of a building from every conceivable vantage point.

Yet, if we consider the constant flow of images in the press, as well as in films and on television, we can feel safe in proclaiming the worldwide triumph of perspective. After all, television screens are in a sense the electronic descendants of the lattice or glass screen used by the authors of perspective treatises to teach people how to view life in an orderly way. No way of looking at the world has gained as widespread acceptance as the one shaped by linear perspective.

Yet, the lenses of the most commonly used cameras have much shallower focus than those of previous centuries. The public is offered little boxes that reproduce nothing but detail. By the same token, machines designed to monitor the movement of enemy aircraft flash bits of computer-fed data instead of images. In other words, vital information—the kind that determines the life or death of an entire nation—is no longer transmitted as a function of vision. The time needed to perceive a pictorial image is now regarded as too long.

All the inhabitants of this planet have a certain kind of space in common. But scientists work with other kinds, as do artists. Unity is gone—perhaps awaiting rediscovery, a new synthesis.

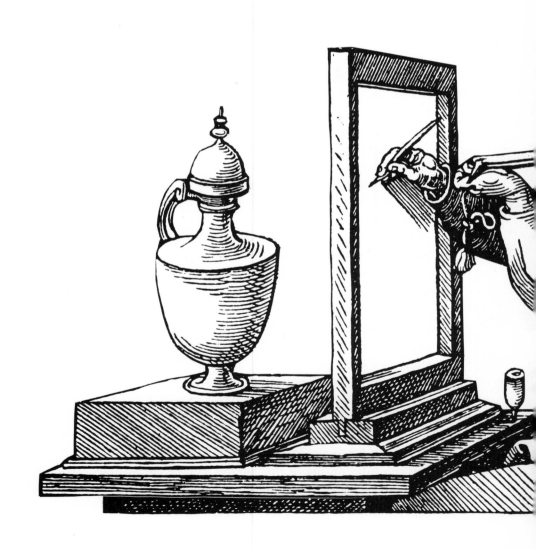

15TH AND 16TH CENTURIES

Antonio di Pietro Averlino, called Filarete (c. 1400-c. 1469). Sculptor, architect, writer. He worked for Lorenzo Ghiberti on the doors of the Baptistery in Florence and also on the bronze doors of St. Peter's in Rome. He planned the Ospedale Maggiore in Milan and the Cathedral in Bergamo. Prior to 1465, he published a twenty-five volume treatise on architecture—André Chastel calls it a "work of science fiction"—in which he created an ideal city, La Sforzinda.

Trattato di architettura di Antonio Filarete, before 1465 (the manuscript consulted in preparing this book is in the National Library at Florence).
This treatise is an offshoot of Leonbattista Alberti's thought. Liliane Brion-Guerry notes Filarete's unusual comparison of the eye to "a magnet, drawing images of objects to the mind like iron filings."

Plate 6: Book 13, folio 93, verso.

secondo noi habbiamo ueduto Signor si Ben basta io uileggero almeno ques
ta partita disotto Auete inteso Signore esiti che abbiamo trouati & anche p̃
disegnio uimandiamo potete comprendere lessere diquello uiscriuiamo aparto
le Siche rispondete quello uiene pare allo architento nostro pare & anche a me
che inquesti luoghi starebbe bene di hedificarsi qualche cosa considerato eluoghi
essere anti & omem Siche lanostra Signoria a inteso sin hora auoi adeterminar
re quello uolete chesifaccia & chepiu uipiace Data nella nostra nuoua cita adi
primo dimaggio anno primo della sua hedificatione sta bene ripiegala chehor
lauoglio mandare uia Ripiegata & suppellata fu mandata al Signore Riceuuta
subito lalesse & inteso quello conteneua lalettera molto glipiacque larisposta sua
fu questa. Abbiamo inteso quanto ciscriui desti dauoi trouati iquali anni mo
to piace ma altro nonuoglio determinare p̃sino nonuegho la p̃che uoglio ueder
collocchio siche amendete pure aspacciare quegli hedifitii cheprincipiati sono dai
douere alpresente fare come sono fatti auisatemi & io uerro & poi diterminer
mo quello sara dafare.

I nteso quanto lasua Signoria nescriue nonaltro facemo senon chel Signore disse che
aogni modo uoleua fare uponti sulfiume indo & su lauerlo siche midisse fa quel
che bel disegnio cheio intendo disargli cheseno begli Signore io no ueduti alcu
ni begli antichi & one ueduti moderni ancora impiu luoghi siche dite anche in
do uolete sifacciano Io mimarauiglio dite tu non ragionando moderno io tidico ch̃
p̃moglio almodo antico segua questi moderni nonfassono piu begli Voi nauete
uisti credo degli antichi & demoderni Epuo essere ma io nongho tenuti troppo
amente eglie ueto, o ueduto quello dipauia & quello dimantoua che molto
lungho sono bella cosa piacemi chesono coperti hoñe ueduto afronzer quanto
chesono ancora begli Ancora passando una uolta daRimine passamo sopra a
uno ponte cheue iquale intesi chera bello & dice chera fatto anticamente ma
io ero tenero danm imodo noñm ricordo neanche queste cose gustare non potê
Signore io oho ancora tutti questi ueduti sono begli ma nulla amo afare co
gli antichi Quello chedite che e aRimino e molto bello Ma io no ueduti ancora
a Roma iquali sono insul Teuere massime quello chesono lasepoltura diAdria
no aoe castel santo agniolo & ilquale ogni di sichiama ilponte santo pietro eue
ne anchora unaltro chesichiama ilponte delisola come eccu ixola inRoma Si
gnore elle neltheuere ede grande assai unaltra uolta uidiri inche modo e & co
me unaltro ancora ilquale sichiama ilponte santa mma ancora questo e bello n̄
quello disanto pietro piu mipiace chenessuno diquesti altri piu chesieno fatti non
cisene uede Vedesi bene leuestige ditre altri come e quello disanto spirito & quello che
sichiama ponte rotto, Eui ancora umpoco dinestigio diquello che ormo soce romp
re neltempo cheporsonna fu acampo aRoma poco diquesto siuede senon quanto si
dice & anche p̃scripture sitruoua p̃Valerio & p̃titolinio & altri ancora nesañ mêtioñ

I o arei caro chetu nedisegniassi uno o due secondo che ame pare chesia piu bello &
poi faremo quello chepiu ciapiacera sono contento Io udisegnero imprima quello di
Roma aoe quello disanto pietro ilquale sin inquesta forma lasua grandezza sie

Prospectiua coia.d. Johānis archiepiscopi Cātuariēsis
fratris ordinis minorū dei psanz ad unguē castigata p exi
miū artiū τ medicie ac iuris utriusqz doctorē ac mathema
ticū peritissimū .B. Faciū cardanū Mediolanensem i ue
nerabili colegio iuris peritorum Mediolani residētem.

¶ Inter phice cōsideratōis studia lux iocūdaʔafficit me
ditātes iter magnalia mathēaticaʔ.certitudo demō
stratōis extollit pclarius iuestigātes. ¶ Perspectiua igit
humanis traddationibus recte pfertur in cuius area linea
radiosa demōstrationū nexibus cōplicatur.Jn qua tā ma
thematice q̄ phice grā reperit utriusqz florib' adornata.
Cuius sñias magnis deductas ābagibus i cōclusiua cōpen
dia coartabo mistis iuxta modū materie nālib'τ mathēati
cis demōstratōibus nūc effectʔ ex causis nūc ex effectibus
cās cōclusurus additis et ñ nullis cōclusionibus que ibi ñ
habentur ex eisdē tñ eliciunt. ¶ Pro ut de luce tractante
lux oium dñs dignabitur illustrare pñs et opusculū i tres
particulas partiturum. .i.

l **Ucez operari inuisum contra se con**
uerium aliquid impressiue.

Hec conclusio probatur sic per effectus quoniam uisus i
uidēdo luces fortes dolet τ patit.Lucis et intēse simula
cra i oculo remanēt post aspectum. Et locū minoris lu
cis faciūt apparere tenebrosuz donec ab oculo uestigiū ma
ioris lucis euanuerit. .ij.

c **Ollorem illuminatum impressiue in**
uisum operari.

Hec cōclusio pbat experimētis sensibilibus. Ampli' ocu
lus super fortē colorē illuminatū luce forti fixa intuitiōe cō
uersus si ad colorē debilius illuminatū se flexerit iueniet
colorē primū secūdo appareter misceri q̄ ñ pōt nisi uesti/
giis eius i oculo derelictis. .iij.

q **Uemlibet punctuz luminosi uel illu**
minati obiectuz sibi medium totuz
simul illustrare.

Hec cōclusio pbatur qñ qlibet pūctus luminosi uel colora
ti uisibilis ē i qualibet pte meiʔ sibi obiecti. Sed non ut
nisi ipzimēdo super uisum igit impzimit secundum omnem

in puncto.g.ultra foramen.Amplius ymaginemur in sole
ar.ulam triangulum dictum non penitus circōscribentem
sed paulo minorem τ sit.k.l.m.circoferentiam suaz sere an
gulis suis aplicantem. Tunc ab hoc arculo procedunt
rotunde piramides quarum nulla potest pertingere peni τ
tus integra usqz ad.g.angustia foraminis ipediente. Po
test forsan aliqua pertingere pūctum aliquem foramini p
pinquiorem uel saltem in ipsa superficie foraminis conten
tum.uerbigratia sit punctus.b.tūc angulus piramidis ter
minate in.b.maior est q̄ angulus terminatus in.g.quia lō
ge breuioris est piramidis .certum autem est q̄ radii pira
midis breuioris ratione maioris anguli quem continent
ducti in continuum directum secabunt radios piramidis
longioris τ qui ante intersectionem fuerant contenti τ in
clusi post intersectionem continentes alios τ includētes
erunt igitur cum predicta minor piramis sit rotunda sequi
tur ut post intersectionem predictam incidentiam faciat
rotundam /sicut patet in figura ubi planicies potest figu/
ras solidas declarare. Patet enim q̄ radii piramidis rotū
de.k.l.m.cadunt in.b.τ ibi sese intersecantes extra pira/
mydem triangularem se dilatant. Amplius si accipian
tur radii a sole centraliter egredientes qui sunt fortiores
alijs radiando ut sunt.τ.a.τ.b.τ.τ.c.ipsi cadent intra dictam
piramidem rotundam secantes eam in punctis.r.s. igitur
saltem post illam intersecationem erit talis piramis rotū
da . Sed certe hec ymaginatio locum habet etiam si sol
esset magne figure quadrāte in ipso.n. esset triangulus ali
quis q̄ posset foramen triangulare recte respicere. Et cir
culus triangulum circōscribens aquo posset piramis rotū
da procedere.Et ita rotunditas sol non esset causa propin
qua nec remota huius rotunditatis incidentie. Ampli'
secundum hoc piramis rotunditatem haberet τ acquireret
subito.s.post intersectionem istarum duarum piramidum
in.n.o.uel.r.s.quia secundum hoc quicquid esset ultra.n.o.
uel.r.s.esset rotundum complete . similiter quicquid esset
citra τ ultra triangulare foramen esset triangulare. Cuius
contrarius est manifestum ad sensum quia uidemus lumen
ipsum paulatim rotunditatem acquirere . dico ergo istam
intersecationem ad rotunditatem posse conferre sed nou

John Peckham (1240–1292). Pupil of Saint Bonaventure at the University of Paris, professor of theology at Oxford, Archbishop of Canterbury from 1279, the same year his *Prospectiva communis* first appeared.

Prospectiva co [mmun] is d. Johanis archiepiscopi Catuariesis fratris ordinis minor dei . . ., Milan, c. 1480.

Roger Bacon (c. 1220–c. 1292), Witelo (c. 1225–c. 1275), and John Peckham all elaborated on the theories of Euclid and Alhazen (d. 1039), applying the scientific method to optics. According to Liliane Brion-Guerry, this edition of *Prospectiva communis* was "widely read and had a significant influence on Italian perspectivists of the Renaissance."

Plate 7: Folio 2, recto (which begins with the word *Prospectiva*).

Plate 8: Folio 3, recto.

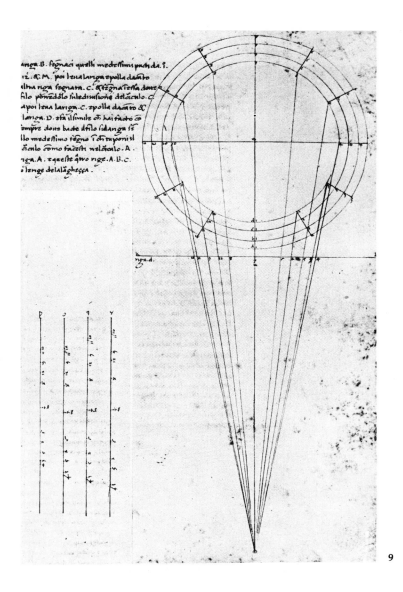

9

Piero della Francesca (c. 1420-1492). Painter (fresco cycle at Arezzo, portraits of Federigo da Montefeltro and Battista Sforza, Misericordia altarpiece, etc.) and theorist. His publications include: *Abaco,* a treatise on bookkeeping, a manuscript copy of which is in the Laurentian Library in Florence: *Libellus de quinque corporibus regolaribus* (after 1480), a geometrical treatise; and *De prospectiva pingendi* (before 1482). The copied manuscript of the *Quinque corporibus,* illustrated with drawings signed by the author, was rediscovered in the Vatican Library in 1880 and revealed that Luca Pacioli's treatise on perspective *De divina proportione* (1509) was a plagiarized version of Piero della Francesca's work.

Two manuscript copies of the treatise *De prospectiva pingendi* exist: one in Latin (drawings only by Piero della Francesca) at the Ambrosian Library in Milan (published 1942), the other in Italian (text and drawings both in the author's hand) at the Palatine Library in Parma (published 1899).

De prospectiva pingendi, a critical edition comparing the Latin and Italian texts, edited by G. Nicco Fasola, Florence, 1942.
This treatise is divided into three sections: perspective of plane figures, perspective of solids (theoretical), and perspective of solids (practical).

Plate 9: Folio 35, recto, from the holograph copy in Italian.

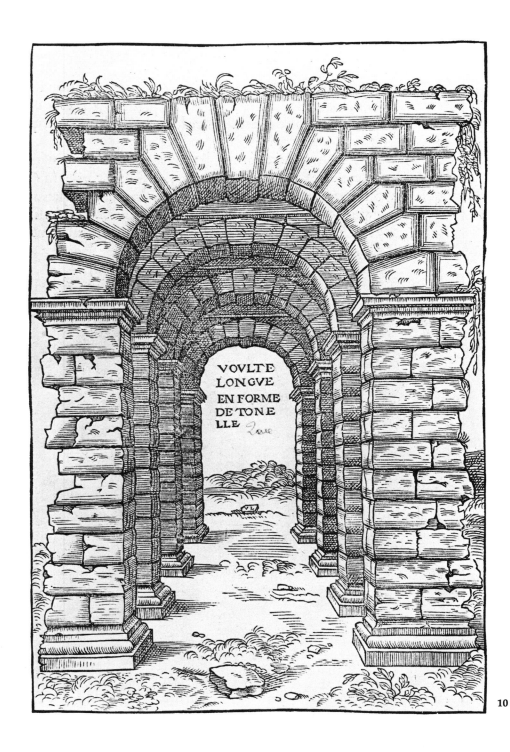

VOVLTE LONGVE EN FORME DE TONE LLE

10

Leonbattista Alberti (1404–1472). Painter, engineer, architect, writer. His architectural works in Florence include the façade of Sta. Maria Novella and the Palazzo Rucellai; others are found in Rimini, Mantua, and Rome, and their influence was felt all over Italy. Writing in Latin, Alberti produced comedies and various treatises, including *De statua* (date uncertain), *De*

pictura (manuscript 1435, printed 1540; the manuscript appeared in Italian as *Trattato della pittura* in 1436), and *De re aedificatoria* (manuscript 1452, printed 1485), a book on architecture.

L'Architecture Et Art De Bien Bastir ... diuisée en dix liures, Traduicts de Latin en François, Par deffunct Ian Martin ... A

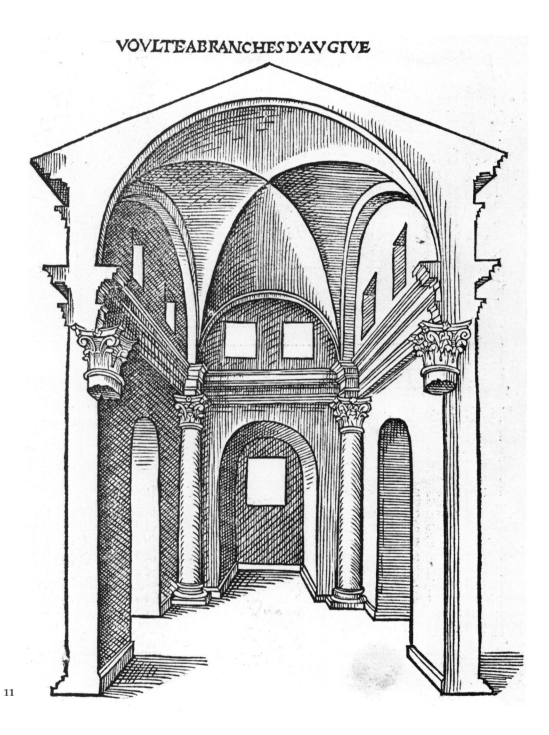

11

Paris, par Iaques Keruer...Rue Sainct Iaques, Avec privilege du Roy, Paris, 1553. (French translation of *De re aedificatoria*). Alberti saw in perspective a redefinition of painting. "The task of the painter is to represent with lines and color the visible surface of any object on any panel or wall so that, at a given distance and in a given position from the center of vision,

it will appear as though three-dimensional and will closely resemble the object " *(Della pittura,* Book 3, para. 2).

Plates 10, 11: In this section of his book, Alberti discusses different kinds of vaults. Plate 10 shows a long barrel vault, Plate 11 an "ogival" or cross-ribbed vault.

† DE·ARTIFICIALI·PSPECTIVA·

·VIATOR·

Ai.

12

Jean Pélerin, called Viator (before 1445-1524).Clergyman, diplomat, theorist, teacher, specialist in perspective representation, architect, secretary to Louis XI and Philippe de Commynes, officer in the service of René de Lorraine. Published a translation of the Book of Job, an encyclopedic catalogue (*Compendium*), and a work on Ptolemy. Canon of the Cathedral at Toul, where he was also master builder, he sketched the tombs of Saint Eucherius at Liverdun and Saint Mansuetus at Toul.

De artificiali perspectiva–Viator . . . [I] *Mpressum Tulli Anno catholice veretatis Quingentesimo quinto . . . opera petri jacobi presbiteri, Incole pagi Sancti Nicholai,* Toul, 1505.
Pirate edition: in *Introductio architecturae et perspectivae,* part of the *Margarita philosophica* of Gregor Reisch, Strasbourg, 1508.
Pirate edition: *Von der Kunst perspectiva,*

by George Glockendon, Nuremberg, 1509.
Second edition: *De artificiali perspectiva,* Toul, 1509, French and Latin text.
Third edition: *De artificiali perspectiva,* Toul, 1521.
Fourth edition: *La perspective positive de Viator, latine et françoise, reveue, augmentée et illustrée par Maistre Etienne Martelange, de la Compagnie de Jésus, avec les figures gravées à La Flèche par Mathurin Jousse,* La Flèche, 1626.
Fifth edition: *La perspective positive de Viator, latine et françoise. Reveüe augmentée et reduite de grand en petit par Mathurin Iovsse de La Flèche . . . par George Griveau, Imprimeur ordinaire du Roy et du College Royal,* La Flèche, 1635. (For Mathurin Jousse, see entry on page 92.)

Plate 12: Title page (first edition).

Plate 13: Representation of the vaulting of Notre-Dame, Paris (second edition). Liliane Brion-Guerry notes that this

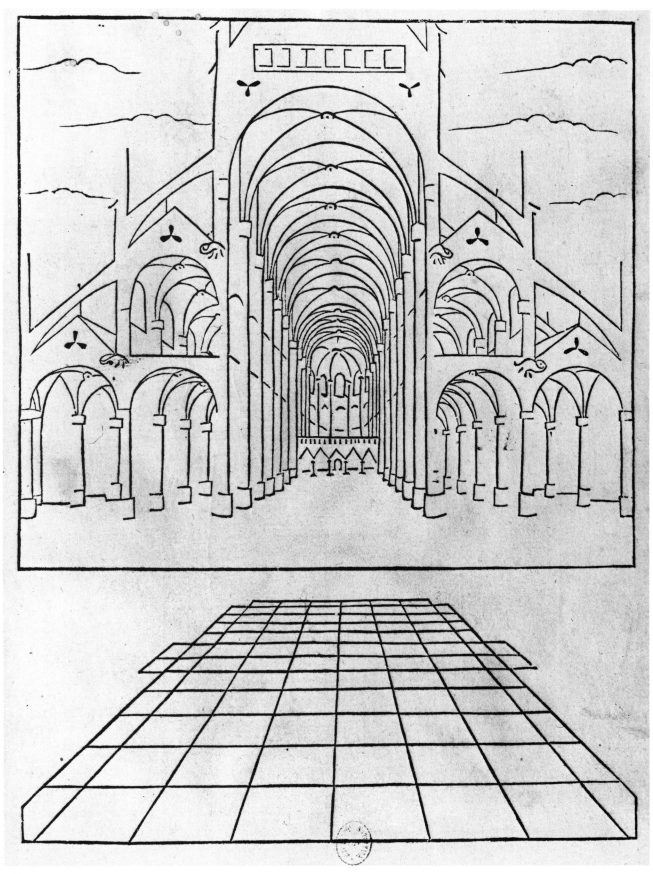

13

14

15

cross-sectional view shows the cathedral as it was at the beginning of the thirteenth century, not as it appeared in Viator's day. It suggests that Viator was acquainted with the old plans and may have collaborated with experts who were looking ahead to its reconstruction.

Plate 14: Monumental portal (first edition). Liliane Brion-Guerry remarks on the similarity between this sketch and three Italian monuments: the portal of the

town hall at Iesi, the *arcata* of the Palazzo degli Anziani, now the Palazzo del Governo at Ancona, and the lavabo in the old sacristy in Pavia, all of which were built by Francesco di Giorgio and his disciples. Published in 1841, Francesco di Giorgio's *Trattato d'architettura* (1482) offers lucid explanations of how churches may be constructed according to the structure and proportions of the human body.

Plate 15: Landscape with trees and hills

16

CARRETA·PELEGRINA

17

(first edition). The following caption was added in the second edition: "Et qui veult limiter les distances d'espace champestre en pourtraiant les droites lignes de pavement soulzfaint aura son intencion: se par autre geometrale industrie n'aura cogneu le faire" (And he who wishes to delineate space in a pastoral scene will be able to do so by drawing straight groundlines, as illustrated below: other geometric skills will prove inadequate to the task).

Plate 16: Clergymen in conversation (first edition).

Plate 17: "Touring cart" (first edition). Probably Jean Pélerin's own wagon in the courtyard of his own house. The perspective drawing shows details of the construction. In the second edition, a caption was added to this drawing:
 En plain chemin / légièrement
 En rude / allez tout bellement.

Albrecht Dürer (1471-1528). Painter, graphic artist, writer. His self-portraits, altarpieces, and prints (the *Apocalypse* and *Large Passion* woodcut series, the famous copperplate engravings *Saint Jerome in His Study* and *Melencolia I)* made him the most famous of all German humanist artists. In 1525, *Underweysung der Messung,* a treatise on geometry, was published; in 1527, *Etliche Underricht zu Befestigung der Stett, Schloss, und Flecken* (on fortifications); and in 1528, a posthumous work, *Hierinn sind begriffen vier Bücher von menschlicher Proportion* (four books on the proportions of the human body).

Vnderweysung der messung, mit dem zirckel vnd richtscheyt, in Linien ebnen vnnd gantzen corporen... [*Hieronymus Andreae*], *zu Nutz alle kunstliebhabenden mit zu gehörigen figuren, in truck gebracht,* Nuremberg, 1525. Second edition: Nuremberg, 1538. ("Hieronymus Andreae," a Nuremberg printer, died in 1566.)

This is not a treatise devoted exclusively to perspective. In the first edition, two different apparatuses for achieving correct perspective renderings are shown in woodcuts. According to a technique already developed by Alberti and Leonardo da Vinci, the artist sketches a portrait with the aid of an eyepiece and a glass panel (the sight fixes the observer's eye as he copies on the glass the outlines of what he sees, later transferring them to a panel or paper by tracing). In the second print, the artist sketches a lute, using a thread attached to the wall by a pin, with a pointer at the near end; a frame with two movable threads that cross each other at right angles is placed between the pin and the lute. Wherever the pointer touches the lute, the place where the string passes through the frame shows the location of that particular point within the picture; it is then fixed by adjusting the movable threads and is transferred to a

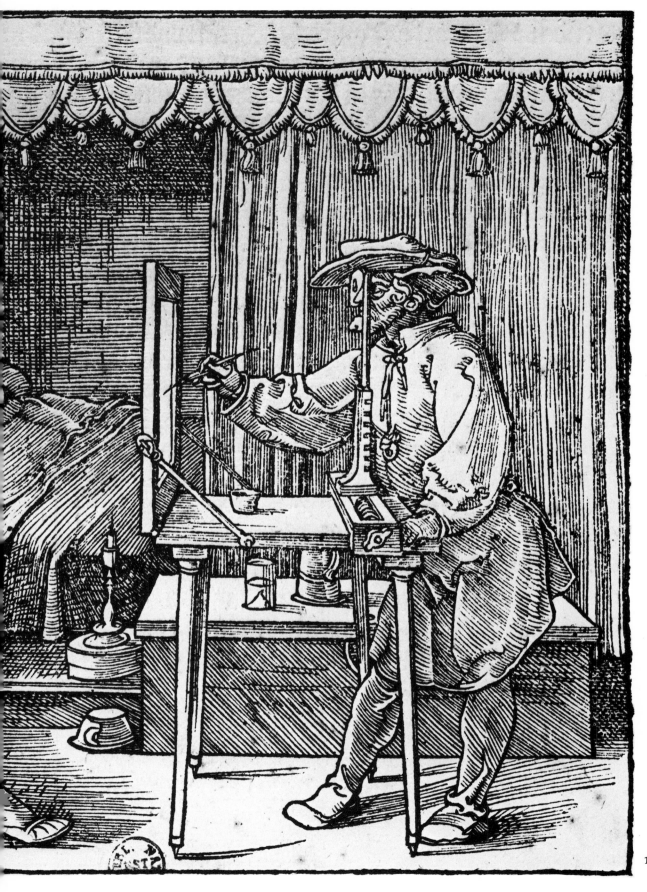

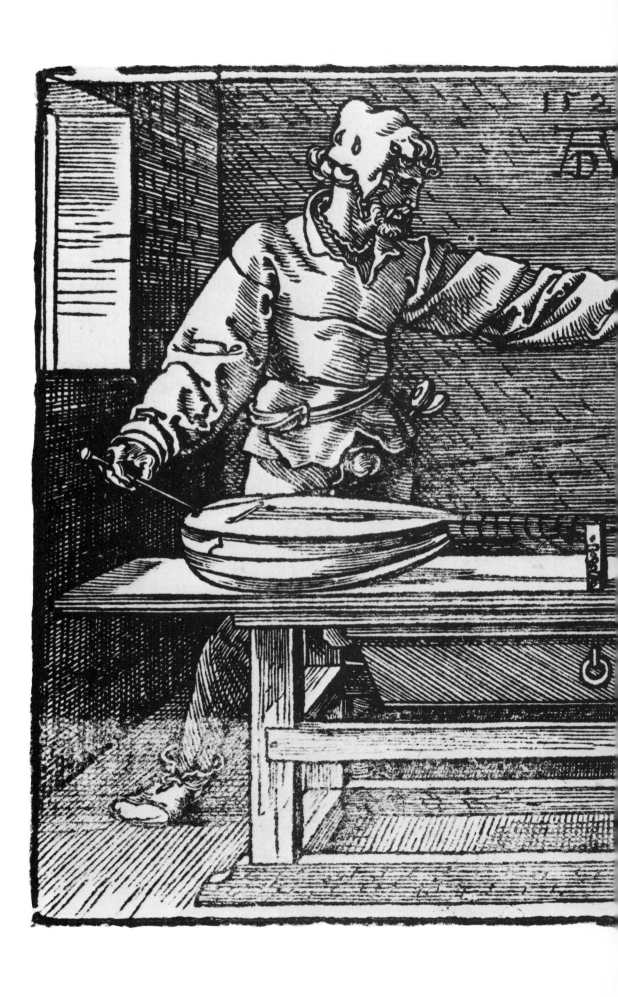

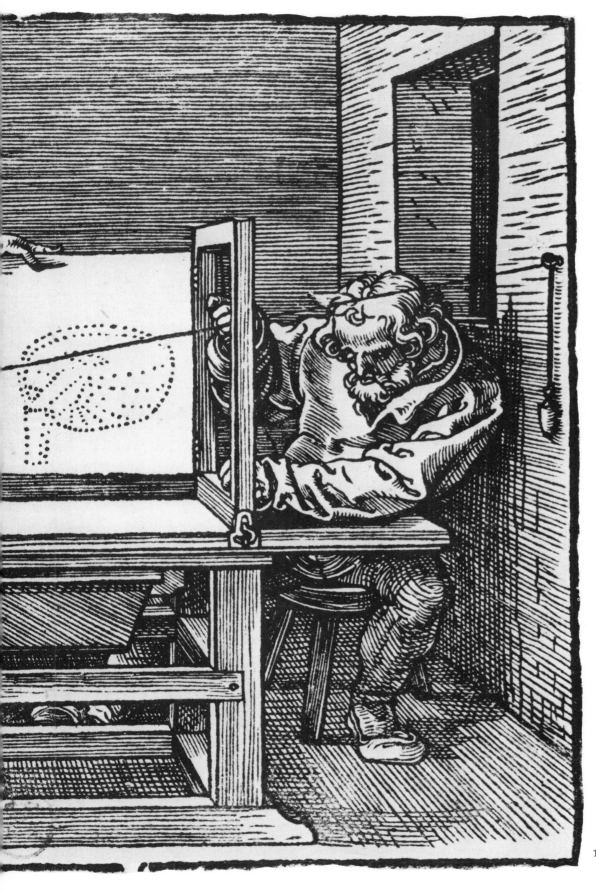

19

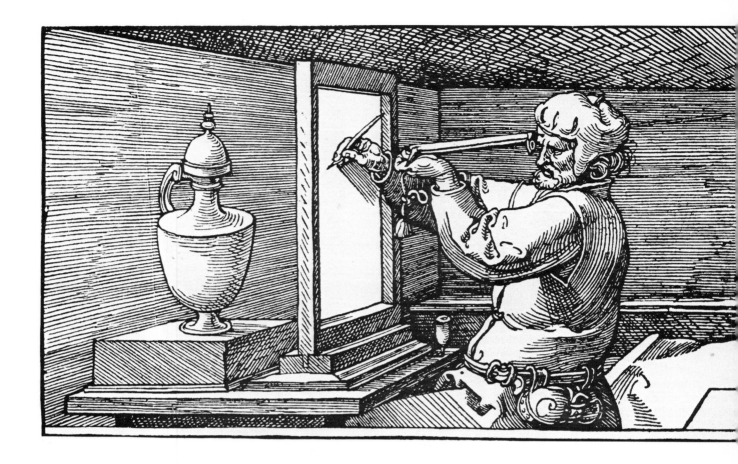

piece of paper attached to the frame.

In the second edition (posthumous), two prints were added: the artist drawing a vase and the artist drawing a nude. In the first, he uses the glass plate and an eyepiece this time attached to a fixed thread to increase his control of the foreshortening; in the second, a frame or glass divided into squares for simplified copying.

Dürer saw himself as an innovator in Germany (the treatise is written in German): "No one is obliged to make use of my lessons; but I am confident that anyone following them will get a grasp of the basic principles. Moreover, through daily practice, his knowledge will grow deeper, and further study will lead him to much more than I show here."

Plate 18: Artist drawing a portrait, 1525.

Plate 19: Artist drawing a lute, 1525.

Plate 20: Artist drawing a vase, 1538.

Plate 21: Artist drawing a reclining woman, 1538.

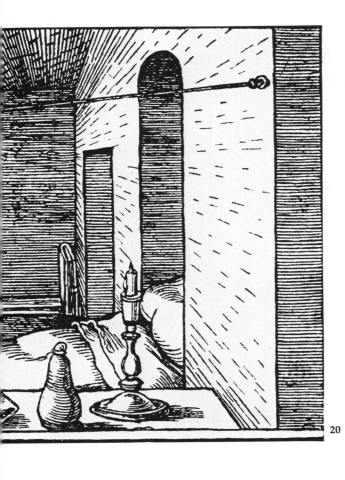

20

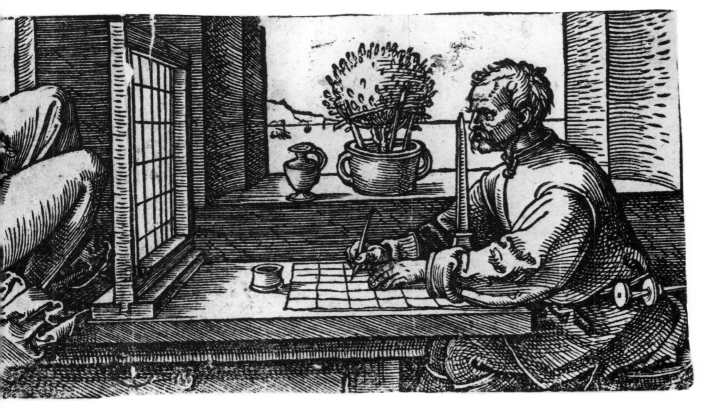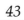

21

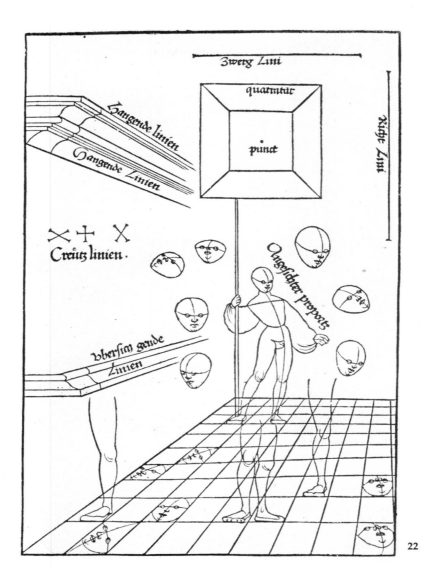

Zwerg Linii

quatmtür

punt

Hangende linien

Gangende Linien

Richt Linii

Creütz linien.

Ongesichter proporc

Vbersich gende Linien

22

Hieronymus Rodler (early sixteenth century). German architectural theorist, town clerk of Simmern.

[*Perspectiva*] *Eyn schön nütlitz büchlin und underweisung der kunst des Messens mit dem Zirckel, Richtscheidt oder Linial: zu Nutz allen...denen so sich der Kunst des Augenmess (Perspectiva zu Latin genant) zu gebrauchen Lust haben....* At the end of the book: *Getruckt uund volnendet zu Siemeren off dem Hunessrucke, in Verlegung Hieronimi Rodlers...S. Jacobs Abent, im Jar nach Geburt Christi...1531,* Simmern, 1531. Republished 1546.
The author addresses his work to craftsmen as an application of Dürer's "overcomplicated" method. According to Albert Flocon, Rodler was a mediocre geometer whose designs were at times "catastrophic."

Plate 22: In this somewhat grotesque illustration, the placement of the heads, feet, and legs of human figures is determined by the pavement, whose tiles are seen in perspective.

Plate 23: This view of a narrow city street is taken from Chapter 9, in which all the principles discussed up to that point are applied practically. Here, the vanishing point is located directly beneath the tower in the center of the picture.

Plate 24: This section of *Perspectiva* deals with constructions in which the vanishing point is located off to the side of the picture.

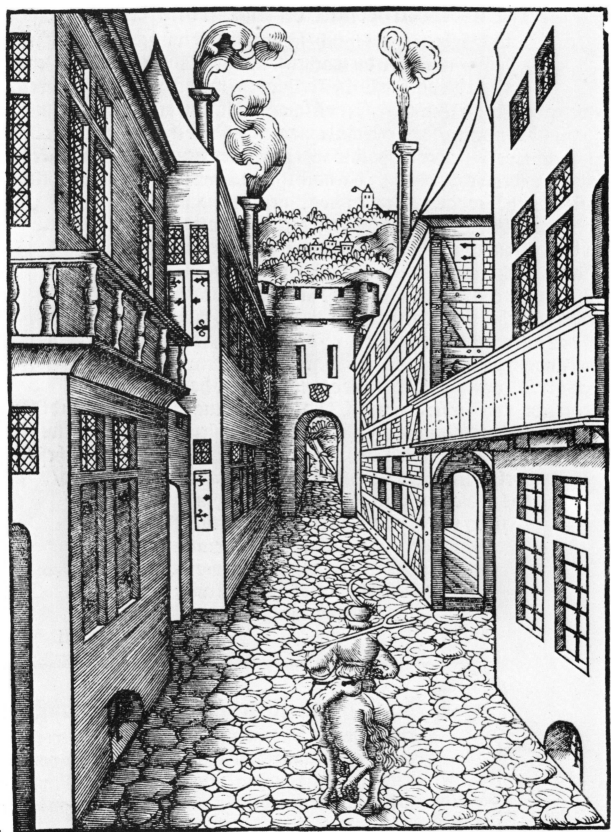

23

Ar nach dem seiten puncten ist diß vnaußgemacht g
heuse genomen/vnd ime iñ allermassen gethan worden/ wie hieu
bei der rechten quadratur angezeygt ist/darumb vonn vnnöten/
weitter meldung daruon zuthun/ darumb es alleyn zů eynem ꝟ
standt/ vnnd daß man ie gern allerley inn disem büchlin anzeygen wollt/ g
macht ist.

F ii

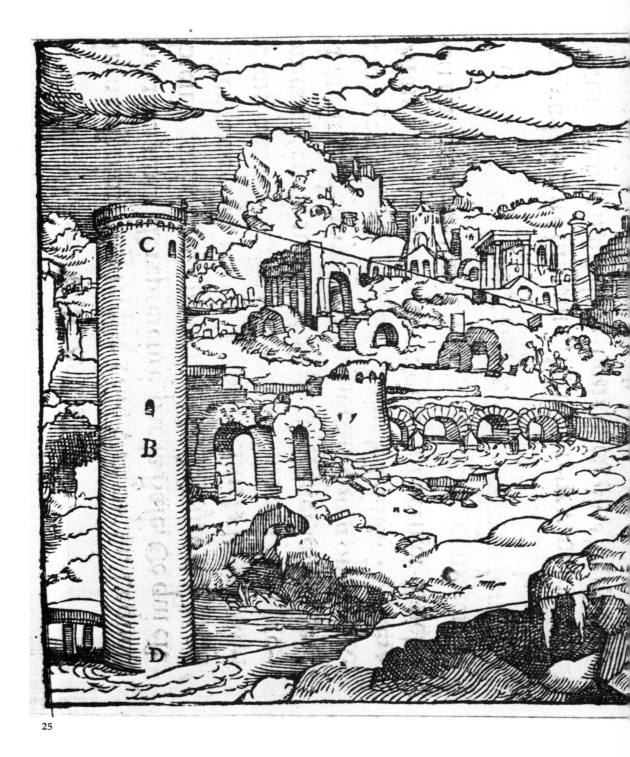

25

Abel Foullon (c. 1513-1563). Engineer, writer, *valet de chambre* of King Henry II of France. Translated the *Satires* of Persius into French (1544).

Usaige et description de l'holomètre pour sçavoir mesurer toutes choses qui sont soubs l'estanduë de l'oeil, tant en longueur et *largeur qu'en hauteur et profondité. Inventé par Abel Foullon, vallet de chambre du Roy. Nécessaire à ceux qui veulent promptement et sans aucune subjection d'arithmétique savoir les distances des places, arpenter les terres et faire des cartes topographiques,* Paris, 1555.

This work was translated into several languages, most notably Italian. In the dedication, Foullon introduces himself

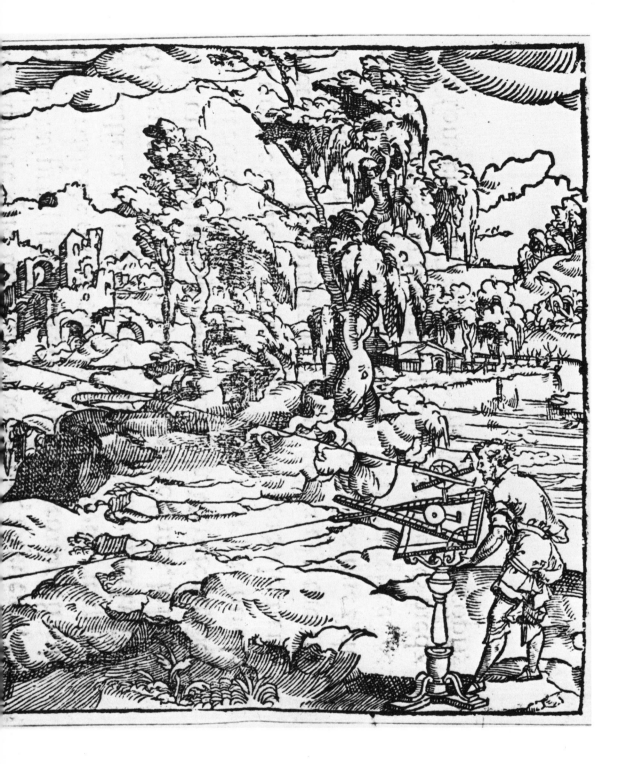

as an engineer interested in such things as the casting of brass (for both artillery and printing type), the placement of mills on top of water tanks, and ways to impel wagons to move by the mere weight of their cargo. He recommends the holometer for those "concerned with laying siege to towns." This device was similar to a surveyor's plane table fitted with two large alidades and several other attachments. It was a complicated instrument but produced measurements instantly and without additional calculations. It enjoyed a vogue before the invention of logarithms and trigonometry.

Plate 25: How to measure the height of a tower with a holometer.

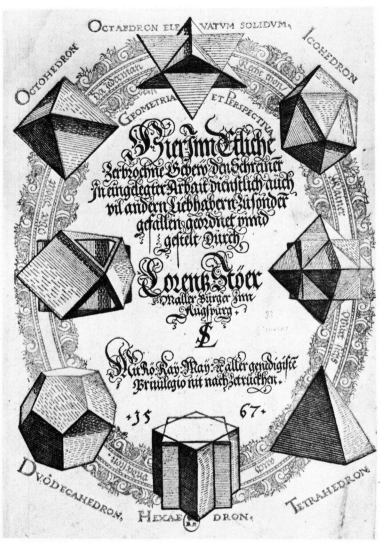

26

Lorenz Stoer (before 1540-after 1620). Painter, graphic artist, jeweler, engraver, burgher in Nuremberg until May, 1557, then in Augsburg until 1594–95, when he returned to Nuremberg.

Geometria et Perspectiva. Hierjnn Etliche Zerbrochne Gebew, Den Schreinern Jn Eingelegter Arbait Dienstlich...Durch, Lorentz Stöer Maller Burger inn Augspurg, authorized in 1555 (first edition published in 1556 under the title *Perspectiva a Laurentio Stoero in lucem prodita*), published in German in Augsburg, 1567. Republished Augsburg, 1617. The twelve woodcuts are by Hans Rogel the Elder.

In Italy, not only the painters but the craftsmen specializing in inlaid cabinetwork were receptive to advances in the field of perspective. As early as the fifteenth century, Fra Giovanni da Verona, Lorenzo da Lendinara, the creators of the Studiolo, or small study, of Federigo da Montefeltro in Urbino, and Guido da Saravallino all had proposed using geometric solids as elements of still life.

Plate 26: Title page (edition of 1567).

Plates 27–29: With astonishing facility, Stoer shows how polyhedrons can be brought into play in a landscape within an architectural setting either under construction or in ruins.

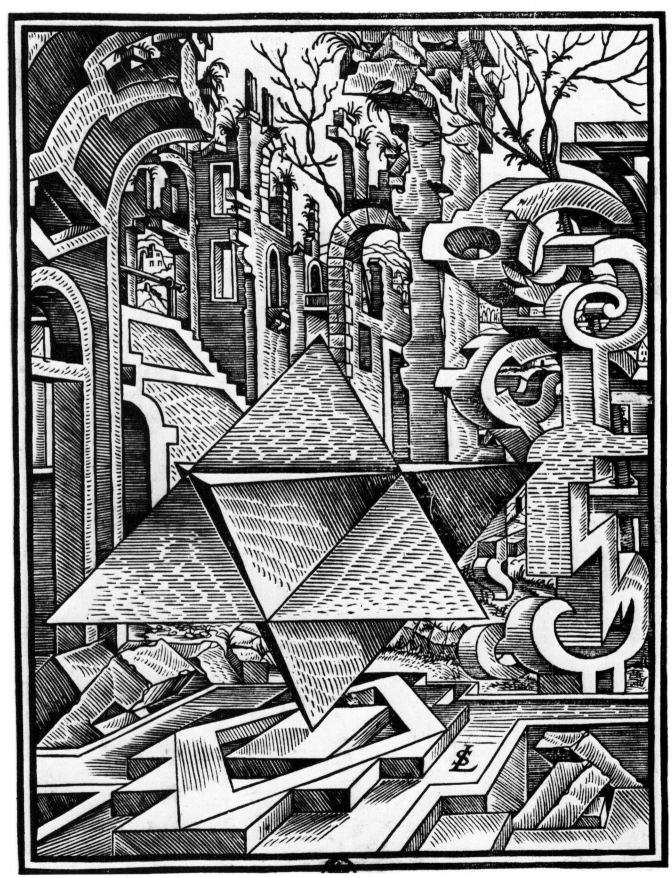

27

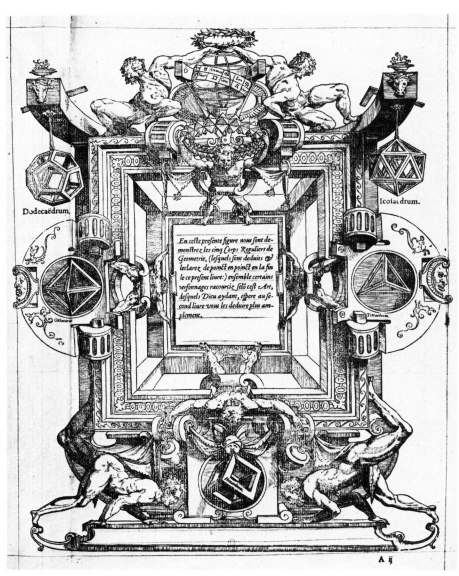

En ceste presente figure nous sont de-
monstrez les cinq Corps Reguliers de
Geometrie, (lesquels sont deduits &
leclarez de poinct en poinct en la fin
le ce present liure:) ensemble certains
personnages racourciz selo cest Art,
desquels Dieu aydant, espere au se-
cond liure vous les deduire plus am-
plement.

Dodecaëdrum.

Icosaëdrum.

Octaedrum.

Tetraedrum.

Jean Cousin the Elder (c. 1490-c. 1560).
Geometer, painter (*Eva Prima Pandora*), il-
lustrator, designer of tapestries.

*Livre de perspective de Jehan Cousin,
Senonois, maistre painctre à Paris, de l'im-
primerie de Jehan Le Royer, imprimeur du
Roy, és Mathématiques. 1560. Avec
Privilège du Roy;* Paris, 1560.

Cousin's *Livre de perspective* retains Via-
tor's procedures. Liliane Brion-Guerry
notes that the frontispiece of Cousin's
work is a duplicate of the one of Viator's
treatise, except that Cousin added
foreshortened figures.

Plate 30: Frontispiece. "In this plate we

see the five regular geometric bodies
(which are enumerated in every particular
at the end of this volume), together with
certain figures foreshortened according to
this technique; we hope, with God's help,
to explain them more fully in the second
volume."

Plate 31: "Various disks arranged as solid
forms seen from above and from the side
as well as from below." In this section,
Cousin undertakes to show how to draw
certain solid figures in perspective, with
the needs of young students particularly
in mind.

Plate 32: How to construct a complex
perspective view of a landscape in several
levels.

de Iehan Cousin.

Exemple de plusieurs Ronds, esleuez en corps solides, veuz tant par le dessus,
par le costé, que par le dessouz.

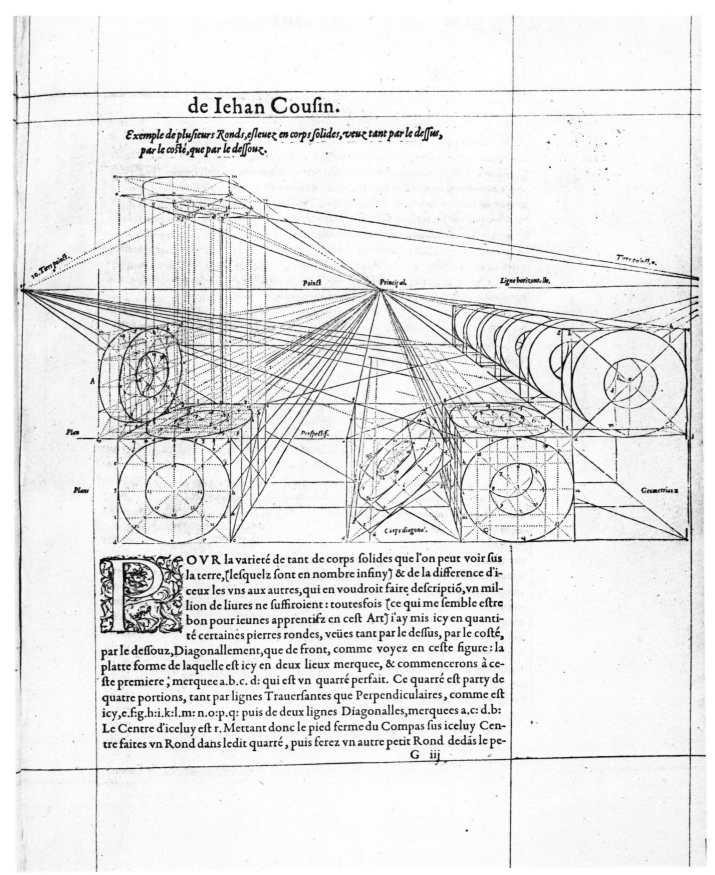

POVR la varieté de tant de corps solides que l'on peut voir sus
la terre, (lesquelz sont en nombre infiny) & de la difference d'i-
ceux les vns aux autres, qui en voudroit faire descriptió, vn mil-
lion de liures ne suffiroient : toutesfois (ce qui me semble estre
bon pour ieunes apprentifz en cest Art) i'ay mis icy en quanti-
té certainés pierres rondes, veües tant par le dessus, par le costé,
par le dessouz, Diagonallement, que de front, comme voyez en ceste figure : la
platte forme de laquelle est icy en deux lieux merquee, & commencerons à ce-
ste premiere ; merquee a.b.c. d: qui est vn quarré perfait. Ce quarré est party de
quatre portions, tant par lignes Trauersantes que Perpendiculaires, comme est
icy, e.f:g.h:i.k:l.m: n.o:p.q: puis de deux lignes Diagonalles, merquees a.c: d.b:
Le Centre d'iceluy est r. Mettant donc le pied ferme du Compas sus iceluy Cen-
tre faites vn Rond dans ledit quarré, puis ferez vn autre petit Rond dedäs le pe-

G iij

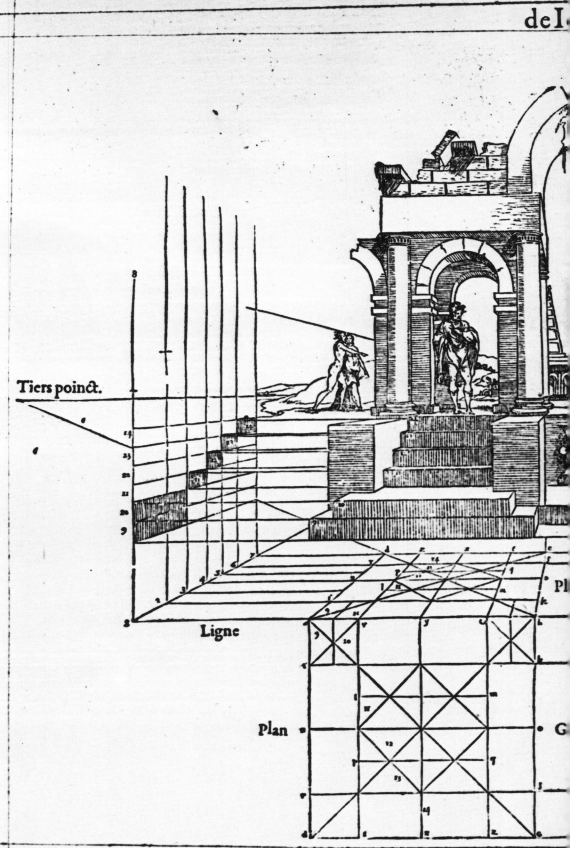

Tiers poinct.

Ligne

Plan

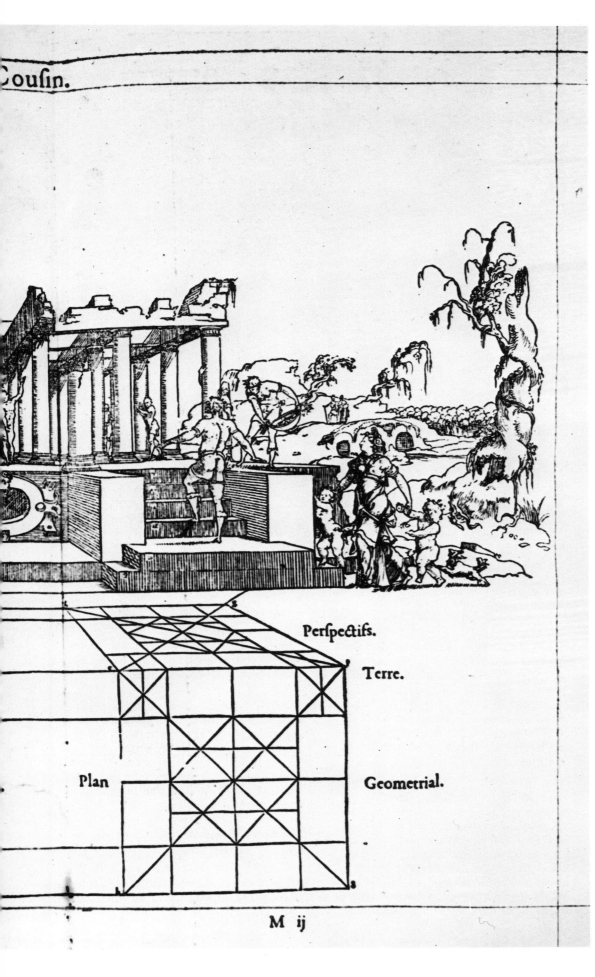

Perſpectifs.

Terre.

Plan

Geometrial.

33

Wentzel Jamitzer (or Jamnitzer or Gamiczer) (1508-1585). Engraver and jeweler. Born in Vienna, he entered into the service of Charles V and various nobles in Nuremberg, where he died. Among his series of etchings, most notable is *Triumphal Arch*. Jamitzer did the sketch for the *Apotheosis of Maximilian II,* later engraved by Jost Amman.

Perspectiva Corporum Regularium. Das īst, ein fleyssige Fürweysung, wie die fünff regulierten Cörper, darvon: Plato inn Timaeo, Uund Euclides inn sein Elementis schreibt, etc.... Und darzu ein schöne Anleytung, wie aus denselbigen fünff Cörpern one Endt, gar viel andere Cörper mancherley Art und Gestalt, gemacht unnd gefunden werden mügen...durch Wentzeln Jamitzer, *burgern und goldtschmid in Nüremberg, mit Götlicher Hulff an Tag geben, etc.,* Nuremberg, 1568. Republished Paris, 1964.

The following is taken from the introduction: "I intend to explain the art of perspective to everyone in so concise and enjoyable a manner that all superfluity will be avoided and—as was the case with the old-fashioned way of teaching—no line or point will be drawn needlessly."

Plate 33: Title page (edition of 1568).

Plates 34–36: Albert Flocon has remarked, "Jewelers of the day emulated sculptors; and Jamnitzer, a jeweler himself, devised 170 possible arrangments based on the sphere, cone, and torus."

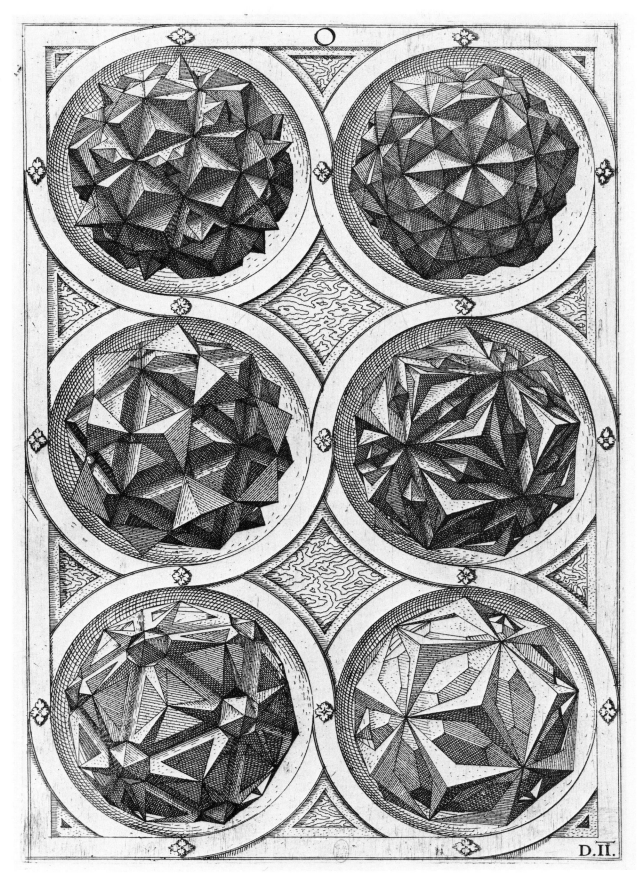

D.II.

34

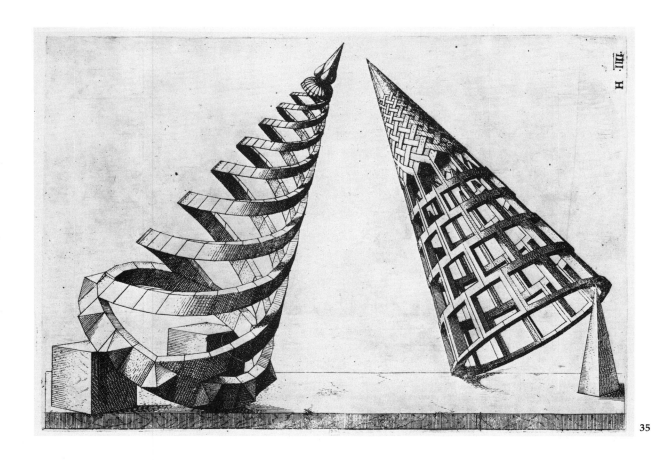

·III· H

35

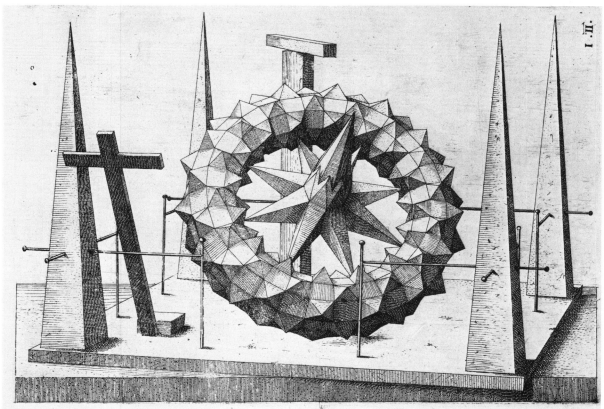

·II· I

36

37

Daniele Barbaro (1513-1570). Chronicler of the Venetian Republic, Patriarch of Aquileia, active at the Council of Trent.

La Pratica della Perspettiva di Monsignor Daniel Barbaro eletto patriarca d'Aqvileia, Opera molto utile a Pittori, Scultori, & ad architetti...Con privilegio. In Venetia, Appresso Camillo, & Rutilio Borgominieri fratelli, al Segno di S. Giorgio, Venice, 1568.

Written with painters, sculptors, and architects in mind, this book shows a strong interest in arranging urban space so as to create a social theater. Its sources are unmistakable: Piero della Francesca (one plate copies the famous *mazzoco,* or neckpiece in perspective) and Dürer (another plate shows the device proposed by the German graphic artist to facilitate drawing in perspective). This was the first published work to give instructions in creating anamorphoses.

Plate 37: Plan and cross section of a temple.

Plate 38: Dürer's mechanical aid for drawing in perspective. (See Plate 19).

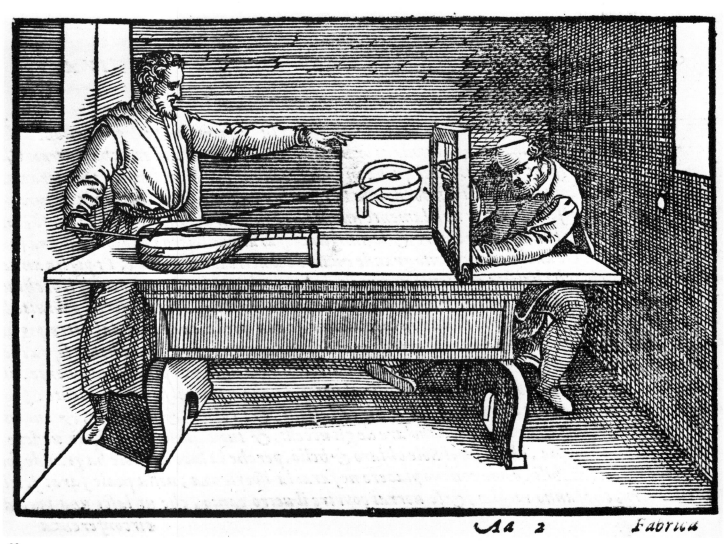

39

Johannes [Hans] Lencker (d. 1585).
Jeweler and enameler from a family of
jewelers in Nuremberg. Worked for
Christian I of Saxony and for the royal
courts of Hesse and Bavaria. Published
Perspectiva literaria in 1567.

*Perspectiva; hierinnen auffs kürtzte be-
schrieben, mit Exempeln eröffnet . . . ein
newer . . . vnnd sehr leichter Weg . . . ferner
in die perspectyf gebracht werden
mag . . . durch Hansen Lencker, burger zu
Nuremberg,* Nuremberg, 1571. The en-
gravings are by Mathias Zyndt. Repub-
lished 1595 and 1616.

Plates 39–41: Like Jamitzer, Lencker of-
fered his readers instruction in showing a
variety of geometric figures in perspec-
tive. Artists and architects were not the
only ones expected to find interest and
amusement in this work. In one series of
engravings, the letters of the alphabet are
drawn in every imaginable position—
slanted, upright, upside down, lying flat.

40

41

l'architetto di fore p uagezza d l'opera

PROFILO

Nel profilo
HI. fondo del marmo
IP. grofezza del marmo
IK. piano digradato
LM. luogo delle figure fopra al gradato
il rimanente p fe è chiaro, oltra quello fintendeua

Primo difegno e del primo architetto

A orizorte con el quale è digrafo il piano
B, linea della diftanza d braza. 16.
D C. linea piana del marmo
G H. linea paralella alla piana ch termina il piano digradato
N panchetta, O, cortinaggio

42

Martino Bassi (1542-1591). Architect. In Milan, he built the Palazzo Spinola. During his work on the Milan Cathedral, he confronted the architect and painter Pellegrino Tibaldi (1527–1596) in a famous dispute about the placement of the horizon line in a bas-relief.

Dispareri in materia d'architettura, e perspettiva. Con pareri di eccellenti, et Famosi Architetti, chi li risoluono. Di Martino Bassi, milanese. In Bressa per Francesco, et Pie. Maria Marchetti Fratelli, Brescia, 1572.

This book records the debate between the author and Pellegrino Tibaldi, who executed a bas-relief at the Baptistery in Milan. Citing Euclid, Dürer, and Sebastiano Serlio, and using Giulio Romano, Raphael, and Mantegna as sources, Bassi also includes letters addressed to him from Andrea Palladio ("the horizon line must be placed in the middle; I am in favor of a single horizon line"), Giacomo da Vignola (who suggests putting the horizon line at a point higher than Tibaldi's), Giovan Battista Bertani, and Giorgio Vasari (who also favored a single horizon line).

The four captions listed below and the plates give an idea of Bassi's line of reasoning and the kinds of adjustments he hoped to make in Tibaldi's bas-relief.

Plate 42: "Initial sketch of the first architect."

Plate 43: "Second sketch, showing the state in which M. Pellegrino left the work."

Plate 44: "Third sketch, showing the first correction I proposed."

Plate 45: "Fourth and final sketch, in perspective, showing the second correction I proposed for said bas-relief."

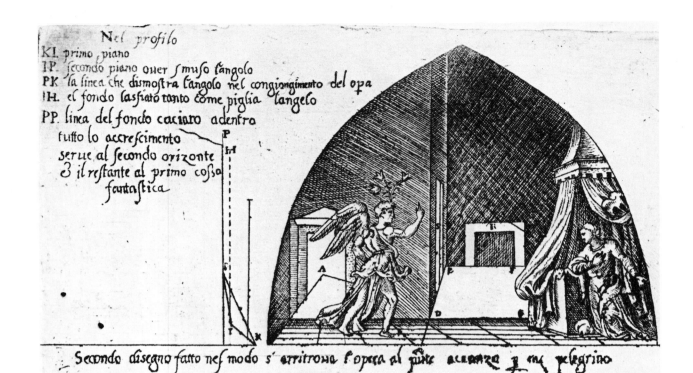

Nel profilo

KI. primo piano
IP. secondo piano ouer smuso l'angolo
PK. la linea che dismostra l'angolo nel congiongimento del opa
IH. el fondo lassiato tanto come piglia l'angelo
PP. linea del fondo caciato adentro
tutto lo accrescimento
serue al secondo orizonte
& il restante al primo cossa
fantastica

Secondo disegno fatto nel modo s'arritroua l'opera al ponte all'ancia p. un pelegrino

B. secondo orizonte
C. linea della seconda distanza di 54
DEFG, piano, o sia smuso secondo

R. camino
S. uscio nel parete V

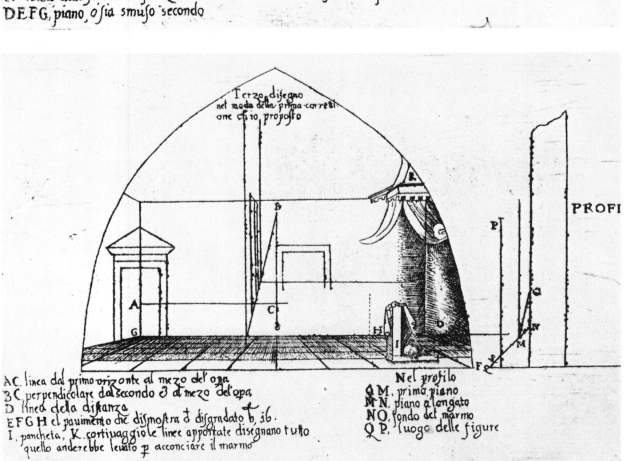

Terzo disegno
nel modo della prima corretti
one ch'io proposto

PROFI

AC. linea dal primo orizonte al mezo del opa
BC. perpendicolare dal secondo & al mezo del opa
D. linea della distanza
EFGH el pauimento che dismostra & disgradato b. 16.
I. pancheta, K. cortiuaggio le linee apportate disegnano tutto
quello anderebbe leuato p. acconciare il marmo

Nel profilo

QM. primo piano
MN. piano alongato
NO. fondo del marmo
QP. luogo delle figure

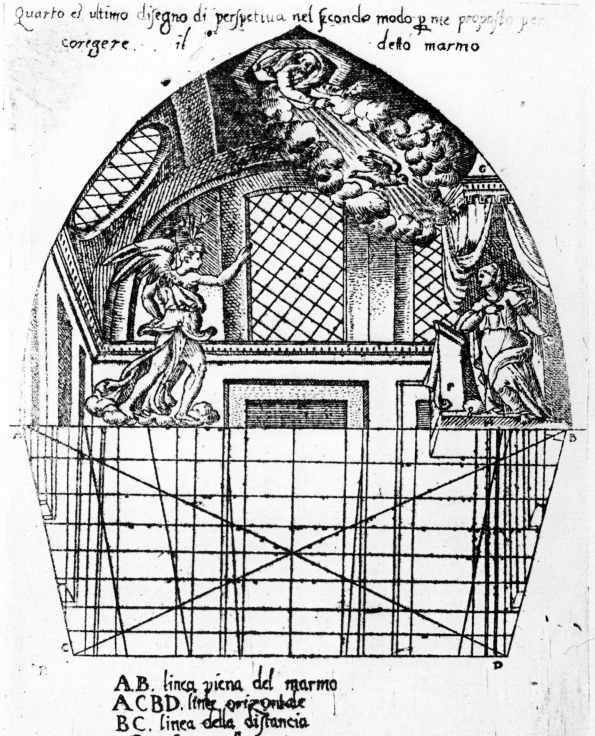

A.B. linea piena del marmo
A C B D. linee orizontale
B C. linea della distancia
F P. aucheta raftremata
G. cortiuagio
 le linee oculte disegnano il piano
 digradato al ingiu
 il rimanente e per fe chiaro

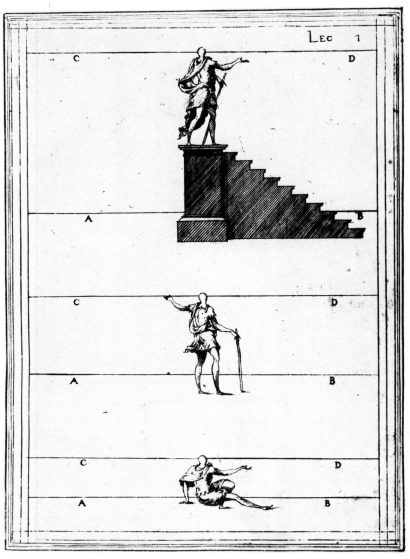

Jacques Androuet Du Cerceau (c. 1520-after 1584). Architect and engraver. Engraved the works of Parmigianino, Rosso Fiorentino, Raphael, and Donato Bramante. Designed the châteaux of Charleval and Verneuil. Among his publications are *Arcs* (1549); *Temples* (1550); *Le Livre d'architecture* (1559); *Arcs et monuments antiques* (1560); *Le Second Livre d'architecture* (1561); and albums of ancient monuments and of grotesques. His *Plus excellents bâtiments de France* (1576, 1579) was dedicated to Catherine de Médicis, as was his *Leçons de perspective positive.*

Leçons de perspective positive. Par Jacqves Androvet du Cerceau, architecte. Paris, M. Patisson, imprimeur, 1576.

The author's confident expectations are apparent in his preface. "If understood, this little book will not only acquaint you with everything hitherto written on the subject; by examining the various drawings of masonry, landscapes, etc., you will also be able easily to determine if the master builders, in their application of perspective, have respected its logic and order."

Plate 46: Lesson 1.

Plate 47: Lesson 31.

Plate 48: Lesson 36.

Plate 49: Lesson 48.

Plate 50: Lesson 52.

Plate 51: Lesson 57.

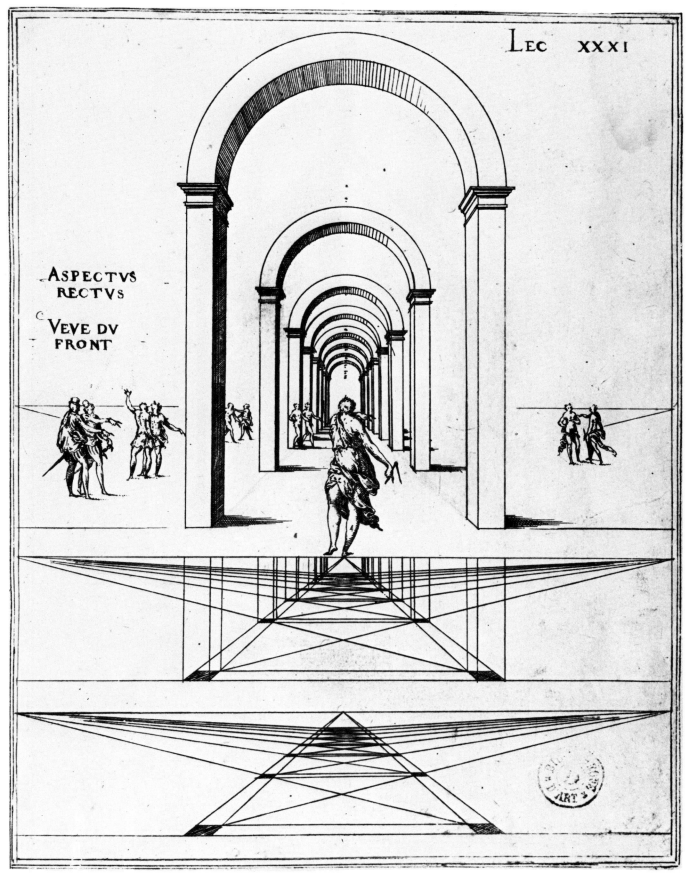

LEC XXXI

ASPECTVS
RECTVS

VEVE DV
FRONT

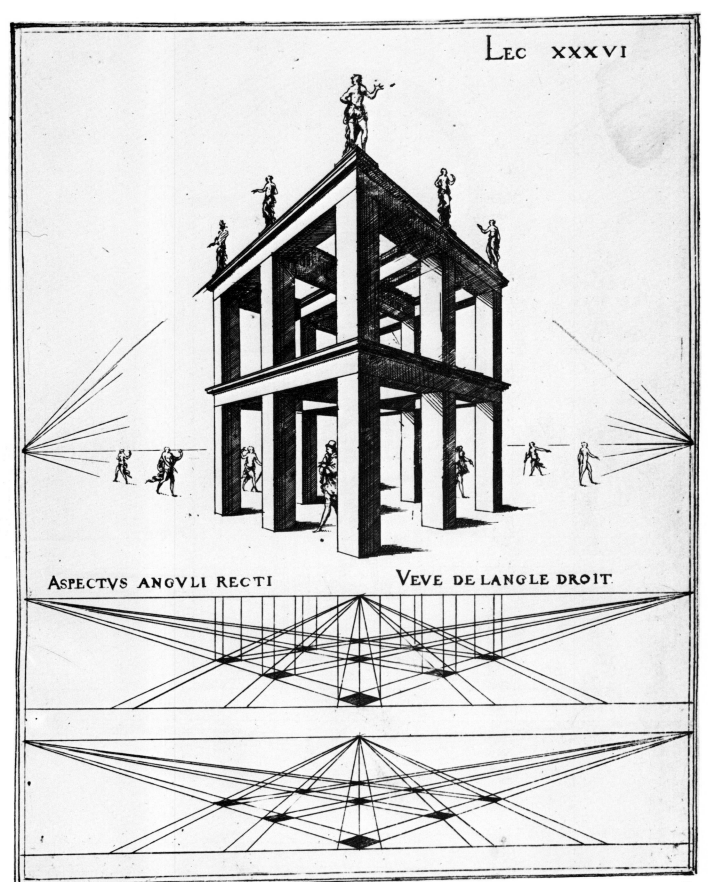

ASPECTVS ANGVLI RECTI VEVE DE LANGLE DROIT.

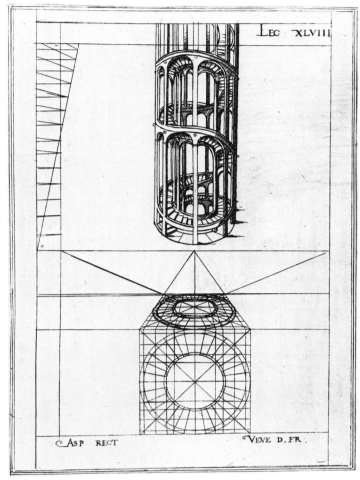

LEC XLVIII

ASP RECT VEVE D. FR.

49

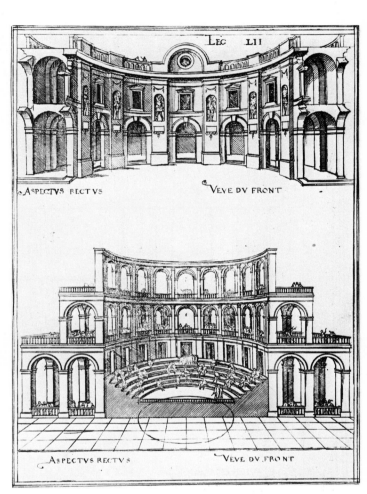

LEC LII

ASPECTVS RECTVS VEVE DV FRONT

ASPECTVS RECTVS VEVE DV FRONT

50

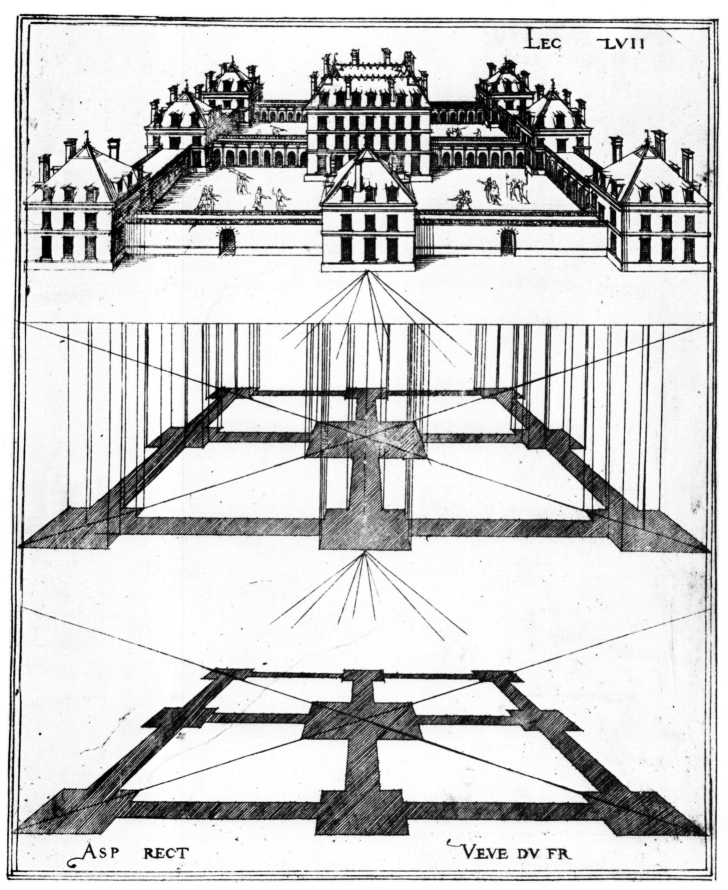

LEC LVII

ASP RECT VEVE DV FR

51

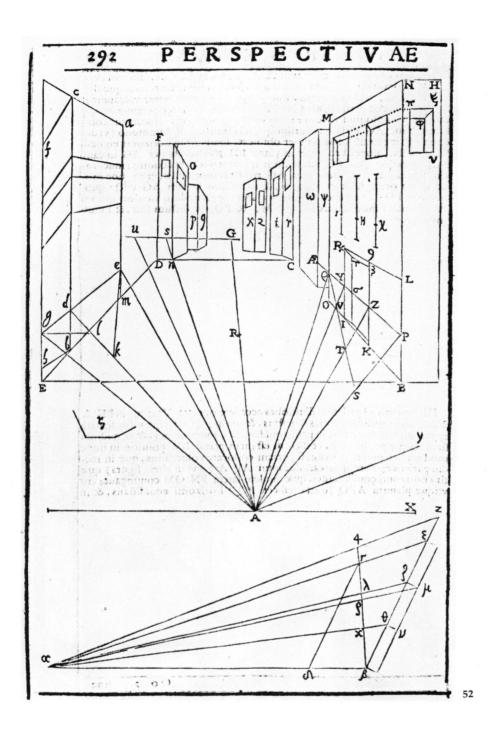

52

73

Guido Ubaldo (1545-1607). Pupil of Federico Commandino. Translator of Greek geometers. Author of *Mechanicorum Liber* ["De Libra, De Vecte, De Trochlea, De Axe in peritrochio, De Cuneo, De Cochlea"] (1577).

Gvidvbaldi e' Marchionibus Montis Perspectivae libri sex, Pesaro, 1600.
Albert Flocon describes Ubaldo's achievement thus: "The author, a geometer, gives twenty-three different methods for [creating a] perspective along a horizontal plane and devises the first projections in perspective on cylinders, spheres, cones, and broken surfaces. He also resolves the problem of accelerated perspective as used in scenery for the theater."

Plate 52: Design for the perspective construction of a plaza.

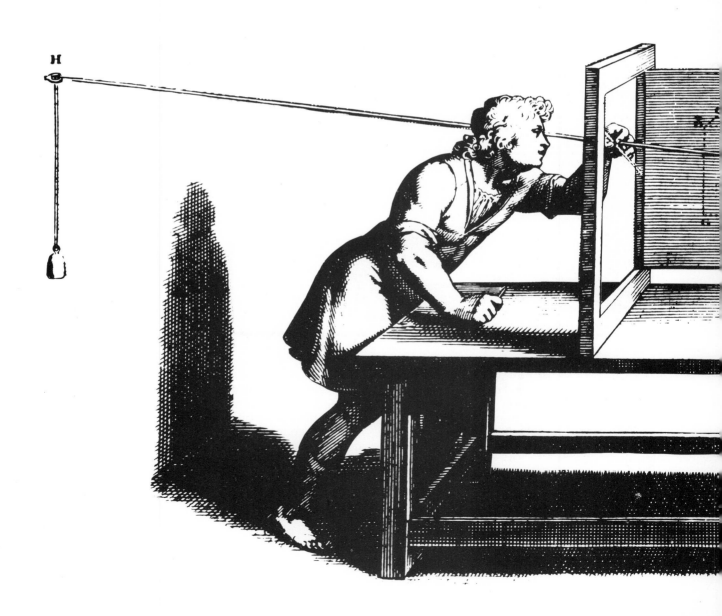

17TH CENTURY

28.

Jan Vredeman de Vries (1527-1604?).
Painter, engraver, architect. Born in
Leeuwarden, he worked in Antwerp until
he was forced to flee by the Duke of Alba's
edict in 1570. As an architect in Germany,
he attempted to found a painters' guild in
Danzig (Gdansk). Worked at the court of
Rudolph II of Prague, then returned to the
Low Countries. Published a large number
of books: garden albums (1565) and al-
bums of architectural fantasies (1601). His
first book on perspective was published in
1568.

Perspective, id est Celeberrima ars in-
spicientis aut transpicientis oculorum aciei,
in pariete, tabula aut tela depicta, in qua
demonstrantur quaedam tam antiqua, quam
nova aedificia...omnibus Pictoribus...et
omnibus artium amatoribus, qui huic arti
operam dare volent, majori cum voluptate,
et minore cum labore. Auctore Ioanne Vre-
deman Frisio. Henric. Hondius sculps. et
excud. Cum Privill. Lugduni Batavorum,
The Hague and Leiden, 1604–5. Dedi-
cated to Prince Maurice of Nassau.
This work has a long history of republi-
cation and revision under the supervi-
sion of Samuel Marolois, later assisted
by the geometer Albert Girard. Engrav-
ings were added especially for the book
by W. Akerfloot. French translation,
1628.

Plate 53: The interior of a room whose
walls, ceiling, and floor are covered with
parallel lines drawn in perspective. Fig-
ures, doors, and windows are positioned
according to their length and distance
from the observer. The way the windows
and doors would look in various open
positions is also indicated by dotted lines.

"We also see three figures, one stretched
out on the ground and two of the same
height, standing. The latter two must be
foreshortened from below, whereas the
one lying down...is foreshortened in the
opposite way, that is, from above. The

entire scene is foreshortened by using a vanishing point and horizon line, keeping in mind that the six and a half units of measurement occupied by these figures should be perceived as the true height of a person, five and one half feet."

Plate 54: This "shows a spiral staircase decreasing in size as it rises from a circular base divided into six sections for half a turn and twelve steps or sections for a whole.... The [next] plate also shows a spiral staircase, but it is foreshortened

only with respect to the turning steps, one complete turn having sixteen divisions or steps.''

Plate 55: Here, a spiral staircase, ''drawn in accordance with the art of perspective, turns four times around the trunk or core of the staircase, each separate step being foreshortened with respect to the horizon line.''

Plate 56: Here, five galleries are shown in a perspective view from above. The perspective construction is made quite clear by the numerous dotted lines.

Plate 57: ''Regarding this first plate in our second section, in which we again discuss the ground and . . . the correct reduction of the first element [the course of paving stones closest to the observer] in accordance with the art of perspective, beginning with those points on the base marked 1, 2, 3, and so on until 15. . . .''

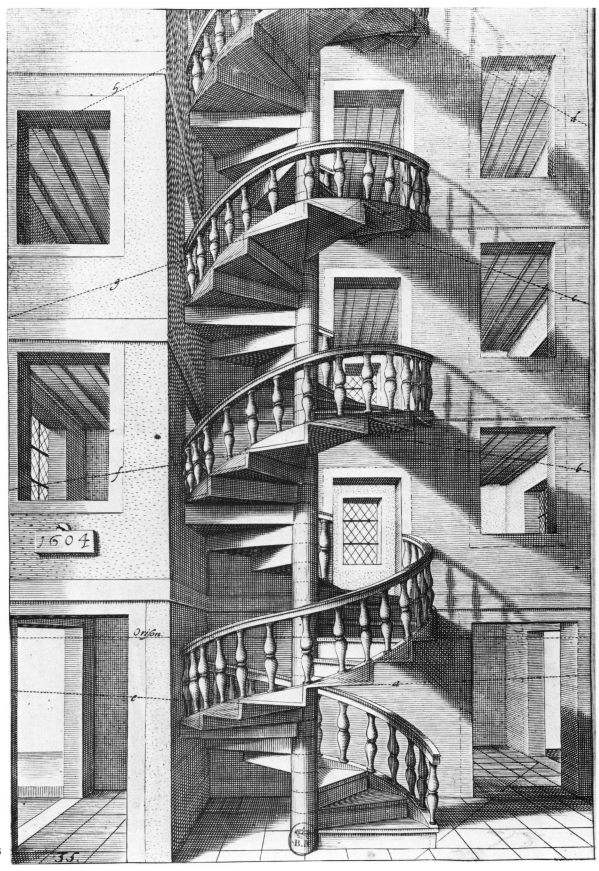

39.

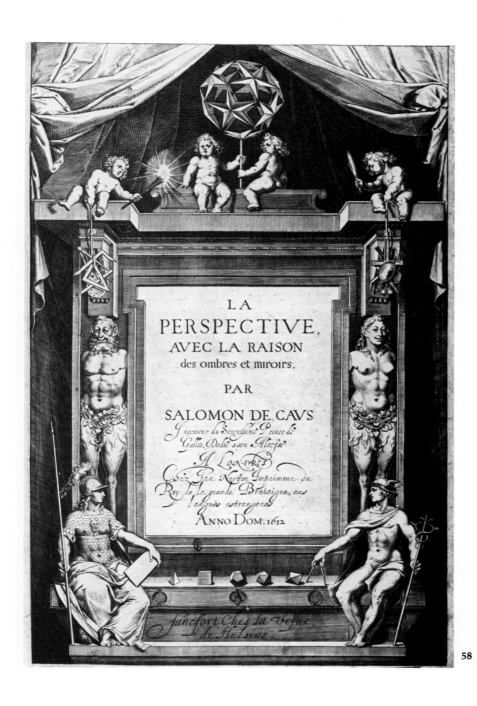

58

Salomon de Caus (d. 1626). Architect and engineer. Worked in Brussels at the court of Albert and Isabella until 1610, then in England for the Prince of Wales around 1611. Starting in 1612, he built the castle at Heidelberg for Frederick V, the Elector Palatine, and then returned to France, where he was architect and engineer to Louis XIII. Published *Les raisons des forces mouvantes* (Frankfurt, 1615), *Hortus Palatinus* (Frankfurt, 1620), and *La Pratique et la démonstration des horloges solaires* (1624).

La Perspective, avec la raison des ombres et miroirs, par Salomon de Caus, Ingenieur du Serenissime Prince de Galles, Dedie a son Altesse. A Londres, chez Pan. Norbon, imprimeur du Roy de la Grande Bretaigne aus langues estrangeres...London, 1612.

This book carries a royal authorization from "Louys, roi de France." From the preface: "Of all mathematics, Perspective alone is pleasing to the eye."

Plate 58: Title page.

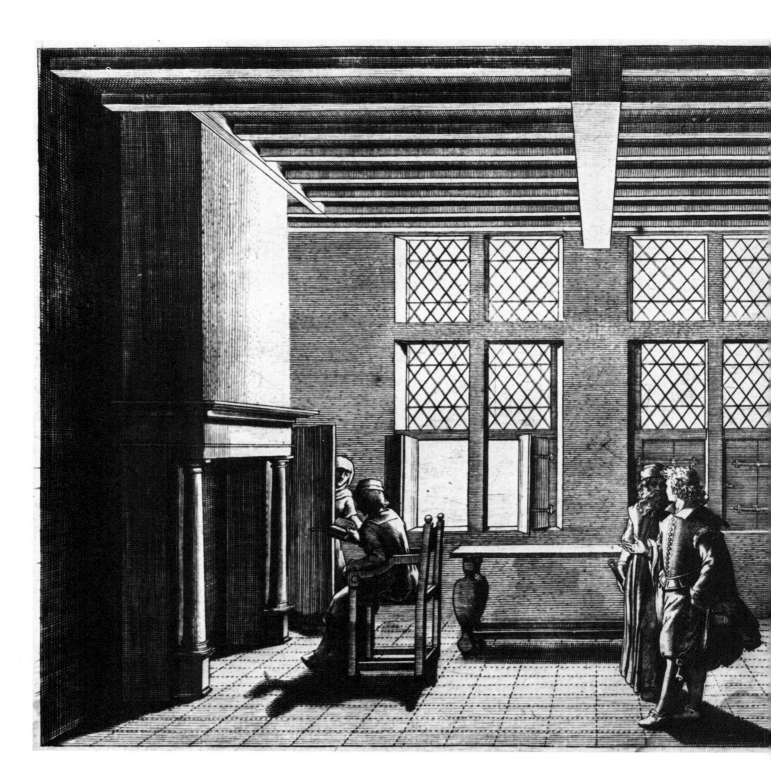

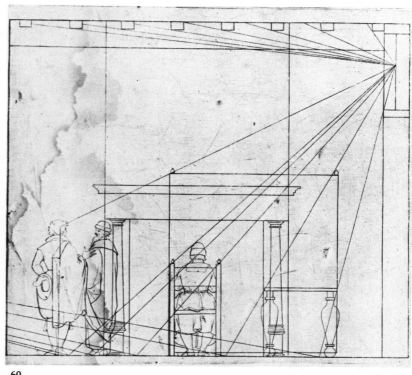

60

59

Plate 59: "How to paint a continuation of a room on the wall of said room with various figures, and also how to arrange shadows for everything depicted in said room" (Book 2: "On Shadows").

Plate 60: "How to paint [a continuation] of a room on the wall of [said] room. ...Drawing no. 3" (Book 2: "On Shadows").

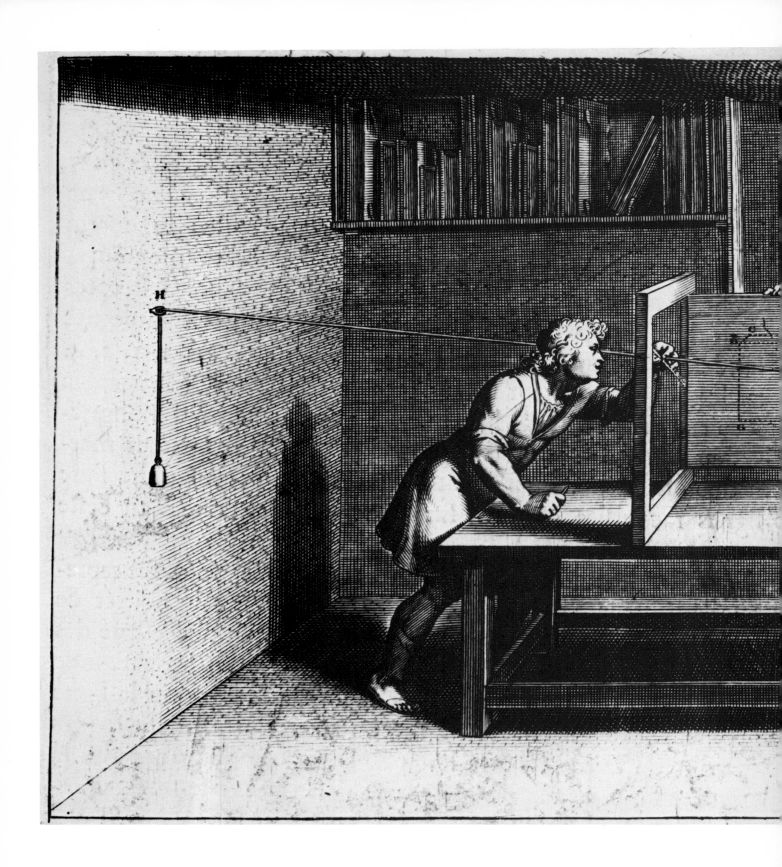

Plate 61: Theorem 10. Another version of Dürer's mechanical aid. (See Plate 19.)

Plate 62: "How to make an inscription on a high wall so that the letters at both the upper and lower levels will seem to be of equal height."

140

63

88

scuno de sudetti, non sono in alcuna parte da questi in misura differenti, anzi sono gl'i-
stessi in tutto, e per tutto come puote vedersi. Hora dico per le cose significate di so-
pra, ciascuna superficie scoperta, & patente all'occhio nostro rimiranti tal ombrifero
Disegno E D F, esser quella superficie, & parte, che nel primiero nostro perspettiuo Di-
segno A B C, restono, & restar deuono illustrate, & lumeggiate da noi, si come per il
contrario, le altre superficie tutte, che in detto ombrifero restano nascose, & celate, es-
ser quelle, che nel sudetto perspettiuo disegno rimangono, & rimaner deuono ombra-
te, & sbattimentate, ciascuna tanto più, o meno intensamente d'ombra, e di lume, &
con più terminato, o sfumato dintorno, quanto vedremo ciascuna ombra crearsi da
più vicina, ò più remota parte dell'opaco, ilche tutto potremo, se cosi ne aggrada con
ogni puntualità osseruare, mediante le passate dottrine.

La qual nostra pratica di lumeggio pare, che rimanghi tanto più singolare, non solo
perche sino hora nell'ombreggiare si è andato alla ventura, & a caso da chi ha rappre-
sentato disegni, & corpi ombreggiati in loro trattati di Perspettiua pratica, ripieni in
vero di mille false incidenze d'ombre, e di lumi, ma anche perche ogni sudetta dottrina
d'ombre, e lumeggi, é tanto euidente all'occhio nostro, ch'egli quasi in vn specchio tut-
te incontinentemente le rauuisa. Et

64

Pietro Accolti (active 1625-1642). Floren-
tine painter and draftsman.

*Lo Inganno degl'occhi, prospettiva pratica di
Pietro Accolti, gentiluomo fiorentino della
Toscana, Accademia del Disegno, trattato in
acconcio della pittura, in Firenze, appresso
Pietro Cecconcelli, 1625, con licenza de
Superiori. Alle stelle medicee,* Florence,
1625. Dedicated to Prince Carlo Medici.
The preface admonishes: "The novice

must first learn the rules and techniques
of Perspective in order to understand
drawing thoroughly."

Plate 63: A cube with an octagon inscribed
in each of its sides, viewed from above.

Plate 64: A cube with an octagon inscribed
in each of its sides: an illustration showing
the position of shadows.

Plate 65: Analysis of a lute.

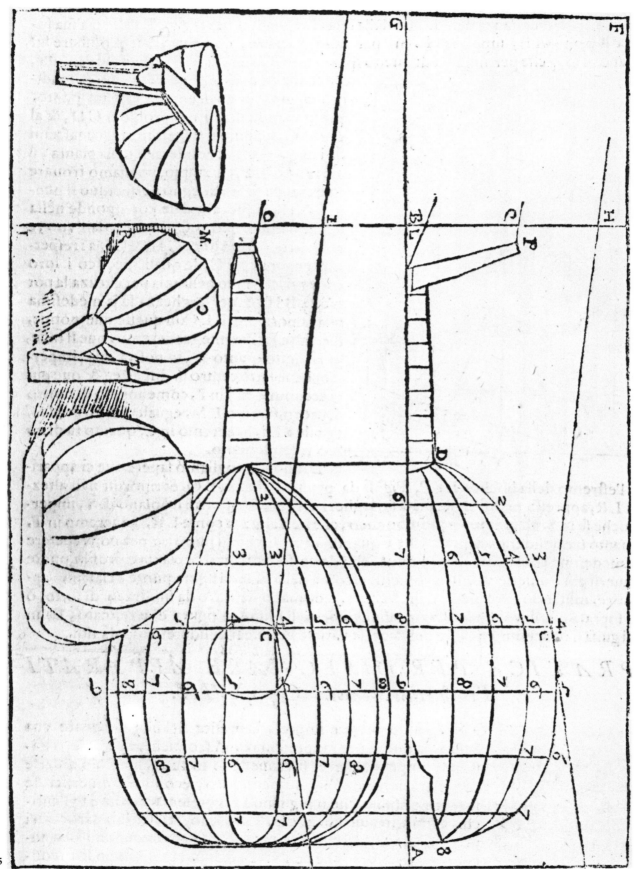

66 67

Peter Halt (n.d.). Architect, engraver, stonecutter, burgher of Schorndorf (Württemberg). Resident of Ulm in 1653.

Peter Halten. Perspectivische Reiss Kunst.

Augspurg, Getruckht durch David Franckhen in Verlag des Authoren, Augsburg, 1625. Engravings by the author.

Plate 66: Perspective view of an orthog-

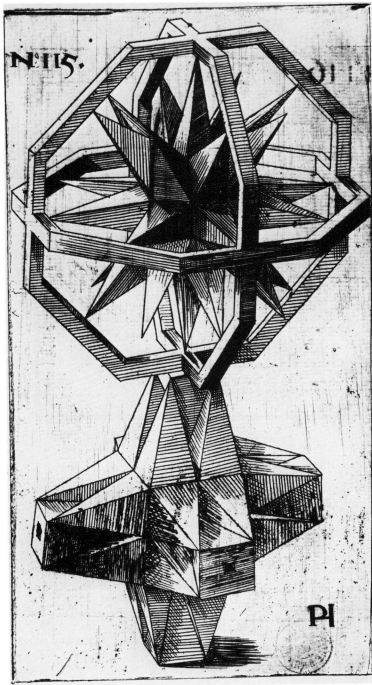

onal structure built around a six-pointed star.

Plate 67: Plan of the structure shown in Plate 66.

Plate 68: Plan of the structure shown in Plate 69.

Plate 69: Perspective view of a polyhedral structure.

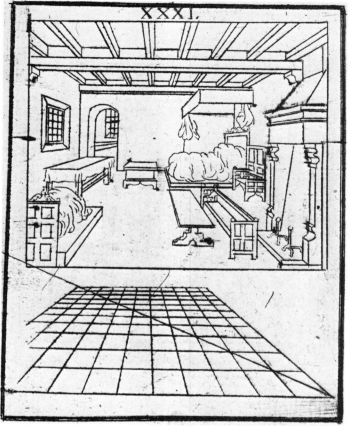

70

71

Mathurin Jousse (1607-before 1692). Ironsmith, engraver, architect, art theorist. Born in La Flèche (Sarthe). Began his career as an ironsmith serving the Jesuits of his native town. Author of important works, including: *La Fidèle ouverture de l'art du serrurier* (1627); *Théâtre de l'art du charpentier et des cinq ordres des colonnes,* (1627–50); *Le Secret d'architecture découvrant fidèlement les traits géométriques* (1642), which includes an attack on the architect Philibert Delorme. Worked on the decoration of the chapel of the Collège de La Flèche (the future chapel of the Prytanée Militaire), which was built by R.P. Martelange between 1607 and 1622.

La perspective positive de Viator, latine et françoise. Reveüe augmentée et reduite de grand en petit par Mathurin Iovsse de La Fleche...par George Griveau, Imprimeur ordinaire du Roy et du College Royal, La Flèche, 1635.

Between the text and the plates of this edition is the following note: "La perspective positive de Viator, traduite de latin en françois, augmentée et illustrée par Maistre Estienne Martelange, de la Compagnie de Jésus, avec les figures gravées à La Flèche, par Mathurin Jousse, 1626." (For earlier editions of Viator's work, see pp. 34.)

Plate 70: Modified version of the original plate (second edition) of *De artificiali perspectiva* with Viator's remark: "Here we see the proper drawing of a room and its furniture."

Plate 71: Illustration of "the extended pyramid...the horned pyramid." This plate, which demonstrates the placement of an object with respect to the horizon, has no counterpart among the original illustrations in Viator's treatise.

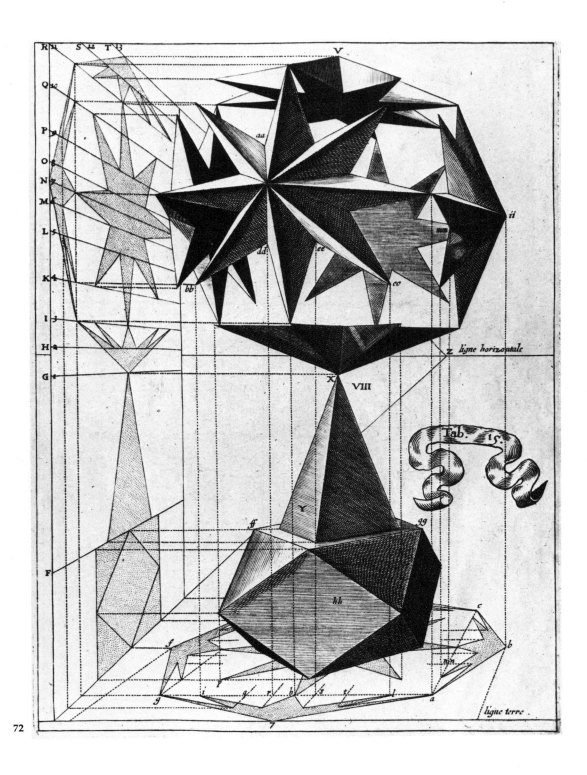

72

Jean-François Nicéron (1613-1646).
Member of the religious order of Saint Francis of Paola (Order of Minims), painter, engraver. Executed an anamorphic painting of *Saint John on Patmos* in the monastery of SS. Trinità dei Monti in Rome and again in the monastery in the Place Royale in Paris.

A monumental example of perspective anamorphosis (a sophisticated application of the laws of perspective probably invented in the West by Leonardo da Vinci), this fresco was intelligible from only one particular place in the room or corridor where Nicéron painted it: from any other, it would have seemed distorted

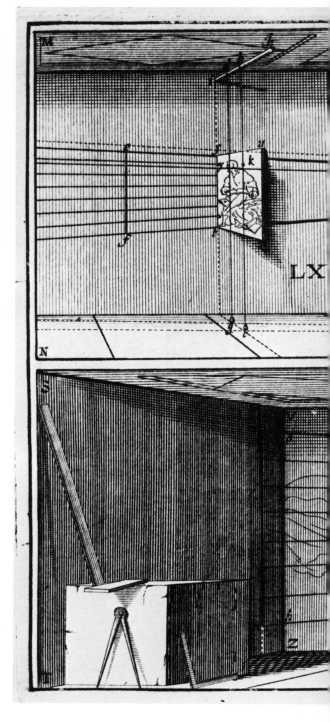

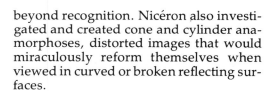

73

beyond recognition. Nicéron also investigated and created cone and cylinder anamorphoses, distorted images that would miraculously reform themselves when viewed in curved or broken reflecting surfaces.

La perspective cvrievse ou Magie artificiele des effets merveillevx. De l'optique, par la vision directe. La catoptrique, par la reflexion des miroirs plats, cylindriques & coniques. La dioptrique, par la refraction des crystaux...Par le père f. Iean-François Niceron...A Paris, Chez Pierre Billaine, rue S. Iacques...Avec privilege dv roy, Paris, 1638.

New edition in Latin: *Thaumaturgus Opticus,* Paris, 1646. New edition in French, published "chez la Veuve Langloys": Paris, 1652, and again, 1663.

Plate 72: Perspective view of a polyhedron (1638 edition).

Plate 73: How a portrait (Louis XIII) can be painted on a cone (conical anamorphosis) in such a way that the image will appear in correct perspective when the viewer looks down at the apex of the cone (1638 edition).

Plate 74: Illustration of the technique Nicéron used to create the fresco *Saint John on Patmos,* in anamorphic projection (1646 edition).

Plate 75: Here, a picture of Saint Francis

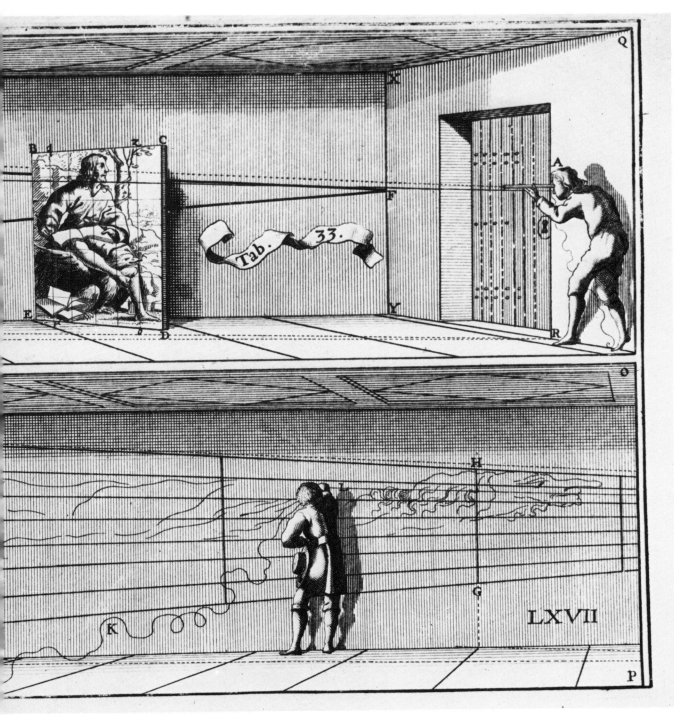

of Paola is turned into a cylinder ana-
morphosis: the image in the curved grid
will appear in correct perspective when
viewed in a reflecting cylinder placed on
the circular area beneath the distortion
(1638 edition).

Plate 76: Portrait of Francis I, king of

France, recognizable only when viewed
obliquely in a mirror. The figure shown
below left, the portrait of a pope, illus-
trates another method of constructing
such an image. The portrait of Francis I
carries the legend: Franciscus/Primus/Dei
Gratia/Francorum/Rex, Christianissimus/
Anno Domini/CICICXV (1638 edition).

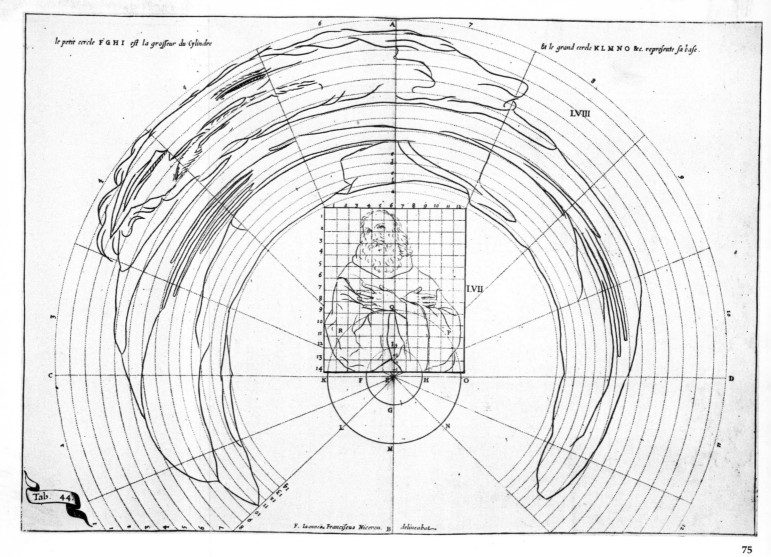

le petit cercle F G H I est la grosseur du Cylindre

et le grand cercle K L M N O &c. represente sa base.

Tab. 44.

F. Ioannes Franciscus Niceron. B delineabat

75

76

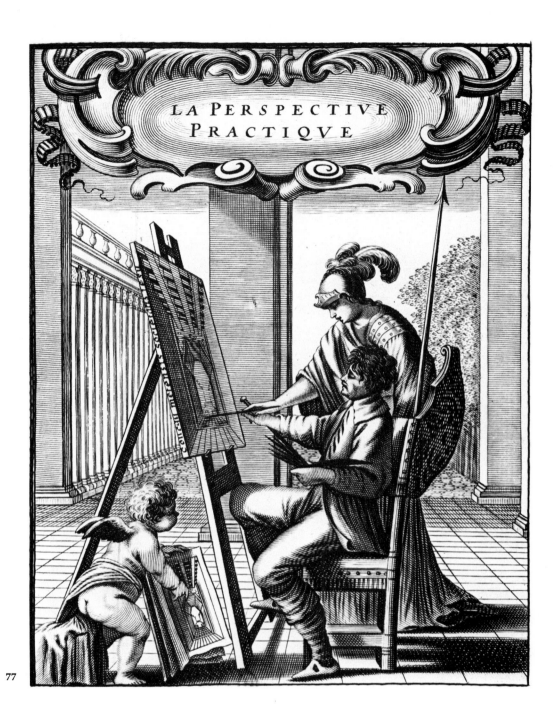

LA PERSPECTIVE PRACTIQUE

77

Jean Dubreuil (1602–1670). Son of a Parisian bookseller, he became a Jesuit in 1624. Spent several years in Rome. Published *Diverses méthodes universelles et nouvelles en tout ou en partie pour faire des perspectives* (1642) and *L'Art universel des fortifications françoises, hollandoises, espagnoles, italiennes et composées* (1665).

La perspective practique nécessaire à tous

peintres, graveurs, sculpteurs, architectes, orfèvres, brodeurs, tapissiers et autres se servant du dessein, par un Parisien religieux de la Companie de Jésus . . . Three volumes, Paris, 1642–49.

To the second edition (1651) was added *Traité de la perspectiue militaire ou methode pour esleuer sur des plans géométraux.*

Sources cited by Dubreuil: "Viator, Dürer, Cousin, Barbaro, Vignole, Serlio, Du Cerceau, [Lorenzo] Sirigatti

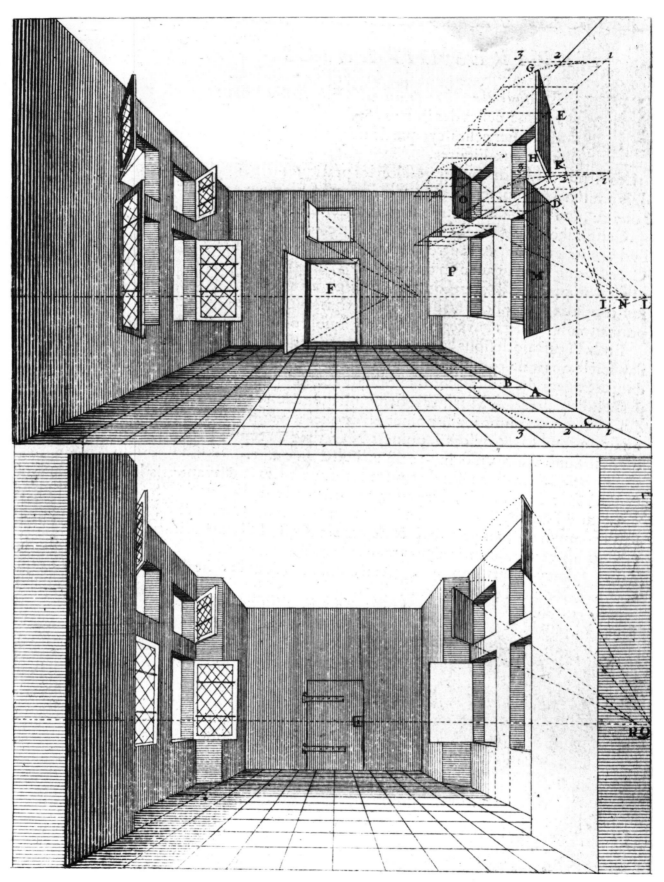

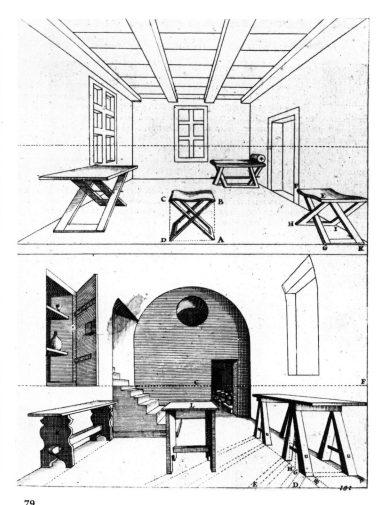

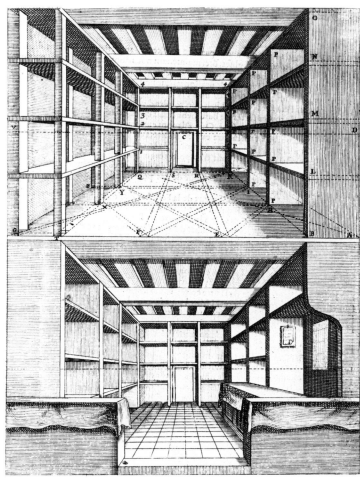

79

80

[author of a sixteenth-century work on perspective], de Caus, Marolois, Vredeman de Vries, Guido Ubaldo, Accolti, Vaulezard [J.L. Vaulezard, seventeenth-century author of treatises on perspective], le sieur Desargues [Gérard Desargues, mathematician and architect], et nouvellement le R.P. Nicéron." The 1642 edition is dedicated, by the editor, to "Monseigneur et très illustre Prince Louis de Bourbon, duc d'Anguien, Prince Mathématicien." The preface warns: "However excellent a painter may be, he must follow all these rules or end up appealing only to the ignorant."

Plate 77: Frontispiece.

Plate 78: "How to render window apertures in perspective."

Plate 79: "Another way to render furniture in perspective."

Plate 80: "Merchants' shops in perspective."

Plate 81: "How to determine the height of distant figures, the first being on a mountain near the observer's eye."

Plate 82: "Shadows, with the sun shining from the side."

Plate 83: "How to render the shadows cast by different objects in sunlight."

Plate 84: "Various positions and lengths of shadows cast by candlelight."

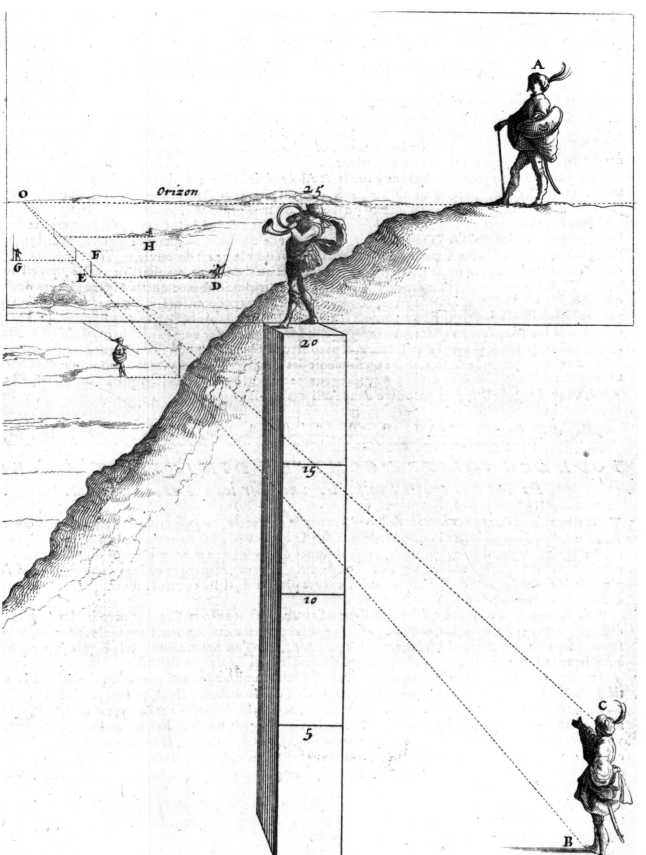

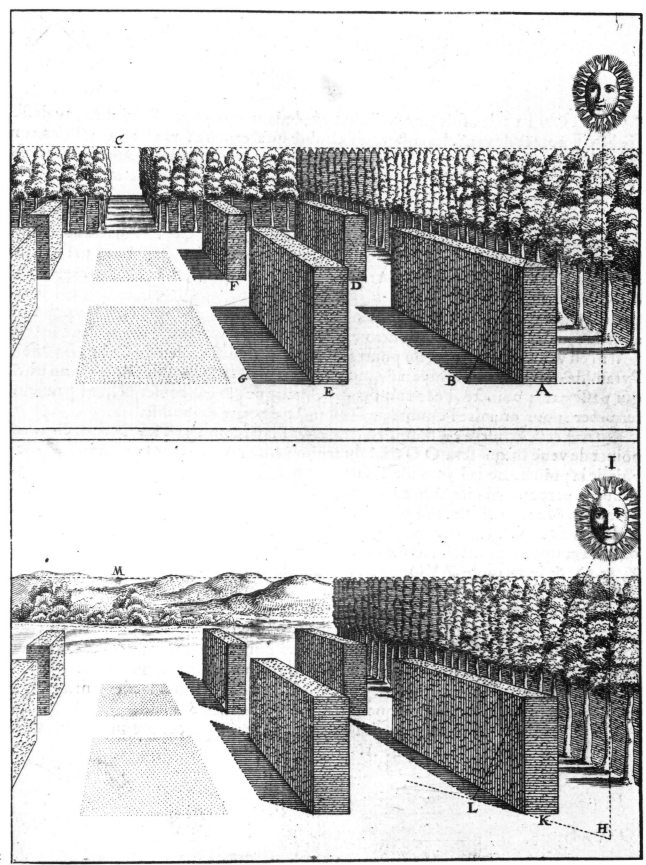

83

84

85

Bernardino di Francesco Contino (d. 1597). Sculptor and architect of Lugano. In Venice, he built the Palazzo Barbarigo della Terrazza (near San Polo) and the tomb of Catarina Cornaro in S. Salvatore. His *Prospettiva pratica* was first published in 1643.

La prospettiva pratica di Bernardino Contino, al Serenissimo Fernandino Medici Gran Duca di Toscana. In Venetia, Venice, 1645.

Plate 85: "How to render a spherical body in perspective."

René Gaultier (n.d.). Gentleman of Maignannes, from Anjou.

Invention novvelle et brìève povr rédvire en perspective, par le moien du quarré, toutes sortes de plans et corps comme édifices, meu- bles, etc. . . . *Sans se servir d'autres points, soit tiers, ou accidentaux, que de ceux qui peuvent tomber dans le tableau, et sans autre dessein que sur iceluy, auec peu de nombres, mesures et transports; et ce par quatre différentes manières. Composé par R.G.S.D.M., angevin, A La Flèche, par*

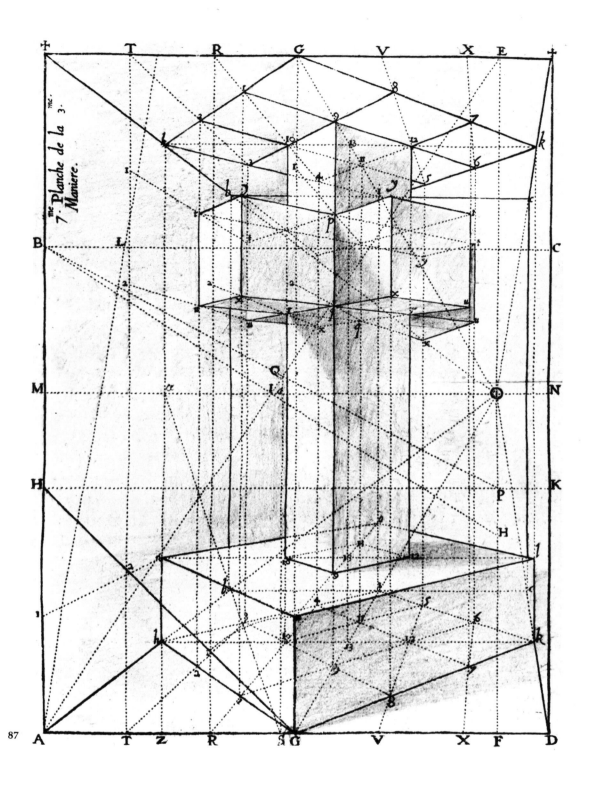

Georges Griveau, imprimeur ordinaire du Roy et du Collège Royal, 1648, avec Privilège du Roy, La Flèche, 1648. Dedicated, by the editor, to Monseigneur Séguier, Chancellor of France. This work claims to be based on the work of Nicéron.

Plate 86: "Plate 6, showing the second manner of execution."

Plate 87: "Plate 7, showing the third manner of execution."

Po.^r parachcuer perspectif sur de tracer le Treillis vne voute Cilindriq.

88

Abraham Bosse (1602–1676). Engraver, influenced by Jacques Callot; theorist, professor of perspective at and honorary member of the Académie Royale de Peinture et de Sculpture (admitted 1651). Published seventeen works, including: *Traité des manières de graver en taille-douce* (1645); *Méthode de pourtraire* (1646); *Traité de mesure des sculptures et des bâtiments antiques* (1656–59); and *Le Peintre converti aux précises et universelles règles de son art* (1667).

Bosse was a friend and disciple of Gérard Desargues, a mathematician and architect from Lyons who studied the mathematical bases of perspective, and Bosse's *Manière universelle de Mr. Desargues*, one of a series of treatises and pamphlets on perspective by Bosse, is based on Desargues's techniques. Bosse eventually quarreled with Jacques Le Bicheur and many other members of the Académie Royale, from which he was expelled in

COMME quelques Particuliers n'ont pas compris dans mon Traitté de la Perspective sa Pratique dans la Representaõn des Objects en toute Sorte de Scituation, et quoy q ou Domes, Iay cru qu'il Seroit bon de l'Expliquer par la representation des Cinq figures pour faire vne bonne Degradation des Objects Sur toutes formes et Scituations de St employer a chaqu'vn qu'vne Distance et vn point de Veüe, telz qu'ils Sont marques par Situe Horisontalement, Car Sil estoit placé Verticalem comme il est en la 2.me fig Cotté

1661 (for details of this dispute, see pages 112-113).

Manìere vniverselle de Mr. Desargves, pour pratiquer la perspective part petit-pied, comme le Géométral. Ensemble les places et proportions des fortes et foibles touches, teintes ou couleurs. Par A. Bosse, graveur en Taille Douce, en l'Isle du Palais, au coin de la rue de Harlay, à la Rose Rouge, devant la Mégisserie. A Paris, de l'imprimerie de Pierre Des-Hayes . . . Avec Privilege du Roy, Paris, 1648.

Moyen vniversel de pratiqver la perspective svr les Tableavx, ou Surfaces Irregulieres. Ensemble Quelques particularitez concernant cet Art, & celuy de la graueure en Taille-Douce. Par A. Bosse. Chez ledit Bosse, en l'Isle du Palais sur le Quay qui regarde celuy de la Megisserie . . . Avec privilege du roy, Paris, 1653.

Traité des pratiques géométrales et perspectives, enseignées dans l'Académie Royale de la peinture et sculpture par A. Bosse. Très utiles pour ceux qui désirent exceller dans les

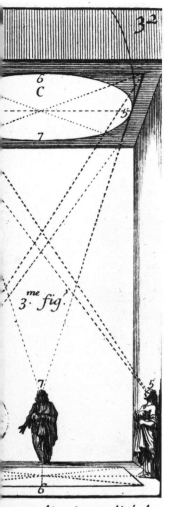

La mesme Chose sur la lumiere du flambeau

90 91

outes, l'Vniversalité de
u dedans des Couppes
t y faire remarquer que
Tableaux qu'il ne faut
le Dome et Tableau est
tain qu'on ne pourroit

arts et autres où il faut employer la règle et le compas. A Paris, chez l'Auteur, en l'Isle du Palais, sur le quay vis à vis celui de la Mégis-serie, Paris, 1665.

Plate 88: "How to draw the perspective grid on a cylindrical vault" (Moyen univer-sel de pratiquer la perspective). A picture conceived on a two-dimensional surface may be transferred correctly to a curved one by means of a grid; in this picture, an artist is shown constructing such a grid.

Plate 89: (Manière universelle de Mr. Des-argues, vol. 1). The figures demonstrate how to understand the notion of lines of vision (rayons visuels), and, consequently, how a shape alters when viewed from dif-ferent angles, by attaching strings to the corners of a rectangle located on the ground and bringing them up to converge in the eye as one assumes different posi-tions.

Plate 90: "As certain details in my treatise on perspective concerning vaulted domes . . . were not fully understood, I thought

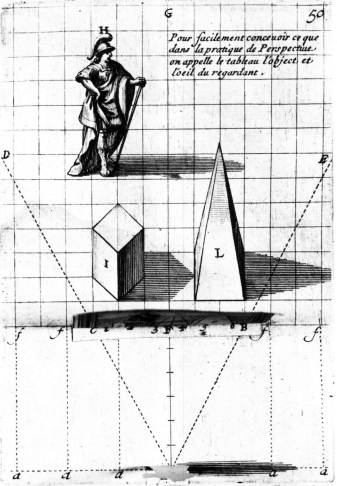

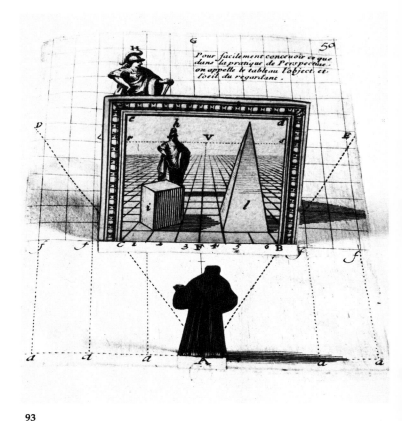

92

93

it would be helpful to explain by the above five figures . . . which show that only one distance, only one viewpoint—not four, as indicated by the horizontally positioned dome [side *C*] in Figure 3—is needed; if the dome were placed in a vertical position (Figure 2, side *B*), the notion of four viewpoints could not be justified." (*Manière universelle de Mr. Desargues,* vol. 3.)

Plate 91: "The same thing by candlelight" (*Traité des pratiques géométrales et perspectives.*)

Plate 92, 93: "How to visualize easily what are referred to in perspective technique as the painting, the object, and the eye of the observer." (*Traité des pratiques géométrales et perspectives*). These are two views of the same plate, in which tabs set up at right angles to the sheet show the figure of the observer (a monk) and the picture (framed) standing upright between him and the objects being observed (two geometric forms and a figure from antiquity).

Plate 94: "On the technique of rapid sketching" (*Traité des pratiques géométrales et perspectives*).

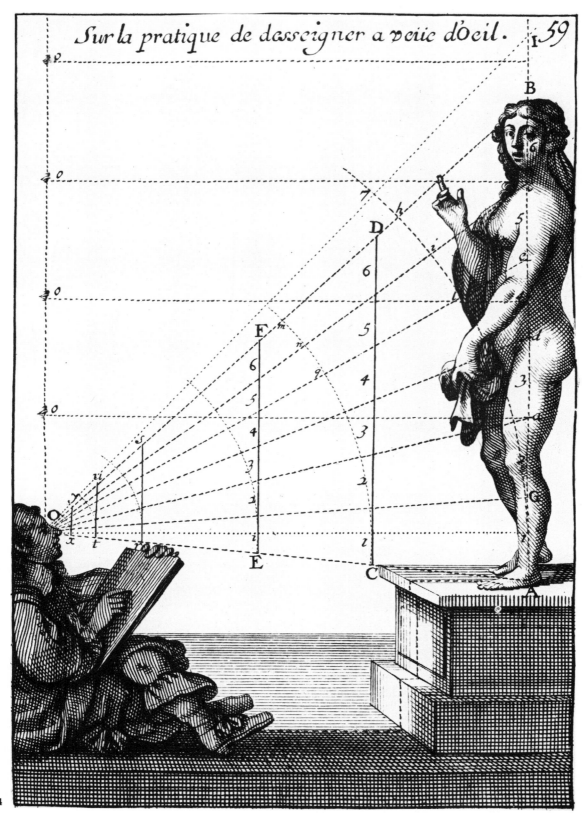

95

Jacques Le Bicheur (1599–1666). Painter, and one of the first members of the Académie Royale de Peinture et de Sculpture. Following are some documents regarding the dispute between Le Bicheur and Abraham Bosse, author of *Manière universelle de Mr. Desargues pour pratiquer la perspective.* Ultimately rooted in a broad and much debated issue—was the basis of correct picture-making strictly theoretical, founded on scientific perspective principles, or subjective, based on established conventions—this dispute became both personal and exceedingly divisive, involving no less a figure than Charles Lebrun, founding member and later director of the Académie Royale.

From a letter from Bosse to the Académie Royale (collection Bibliothèque de l'Ecole des Beaux-Arts, Paris):

2/23/1657. "I have learned that M. Le Bicheur intends to publish [a work on] perspective technique that M. Lebrun says he prefers to the one written by M. Desargues."

From the minutes of the Académie Royale:

7/3/1660: "On this day Monsieur Bosse submitted to the Academy a letter concerning the treatise on perspective of Monsieur Le Bicheur; in that a member of the assembly objected to said M. Bosse's credentials, the latter became highly excited and withdrew, where-

upon the assembly postponed its deliberation to another day."

7/31/1660: "On this day, Messieurs Bosse and Le Bicheur submitted testimony relating to their dispute to the Academy. As the Academy had not had a chance to consider the matter in depth, a decision was put off for another day, whereupon said M. Bosse withdrew angrily."

8/5/1660: Bosse published the following pamphlet against Le Bicheur:

Cahier suivi d'une stampe donnée par A. Bosse, en suitte d'une lettre à Messieurs de l'Académie royale de la peinture et sculpture, contenans preuve des copiemens, estropiemens et déguisemens de la manière de perspective de Monsieur Desargues faite en plagiaire par I. Le Picheur (Pamphlet based on a letter to the Members of the Academy, containing proof of the duplications, disfigurements, and falsifications of M. Desargues' style of perspective as plagiarized by J. Le Bicheur).

From the minutes of the Académie Royale:

5/7/1661: "Taking into account precedents pertaining to the suit brought by M. Bosse against M. Le Bicheur; having heard the response of said Le Bicheur and his subsequent complaints against said Bosse, and the complaints of M. [Charles] Errard [an influential painter and architect whom Bosse had made his enemy] against Bosse, together with the report made concerning the conduct and letter of said Bosse; having examined said letter and conduct; all things considered, the Academy declared null and void Bosse's letter of admission as well as the instrument for which he extorted signatures, revoking all rights and privileges accorded to him, forbidding him further entrance into the Academy, refusing to accept or read any future pamphlets of his, but ordering that two members be delegated to examine said treatise on perspective of M. Le Bicheur, that it may be evaluated according to their report." This statement was signed by Michel Corneille, François Girardon, and Le Bicheur.

Traicté de Perspective, faict par un peintre de l'Académie Royale, Dédié à Monsieur Le Brun, premier peintre du Roy, à Paris chez Jollain, rue Saint-Jacques, à la Ville de Co-

Theoreme 1 8

De quelque distance que l'œil soit éloigné d'vn triangle eleué sur la terre, pourueu qu'il soit a la hauteur du Sommet de ce triangle. Il Luy semblera Couurir Vne Espace paralelle et infinie en longeur.

Ce theoreme est le fondement de la demonstration mecanique dont voicy la figure, en laquelle par deux triangles de carton est represente le racourci en perspectiue d'vn plan geometral sur lequel ils sont posez. il y a aussi deux autres cartons ou est figuré l'œil de l'homme, au centre duquel est attaché vn filet a la hauteur du sommet du triangle: et ce filet faict icy l'office d'vn rayon visuel. de toutes ces choses ainsi establies, ie ferai ma demonstration par deux principalles obseruations.
I. Que les lignes radialles nous representent les lignes paralelles estendues en longeur au plan geometral: parceque si vous dressez les triangles de carton parallellement aux cartons ou est figuré l'œil de l'homme, et que vous conduissiez le filet le long des paralelles en longeur qui sont nottez A.B. et A.B. Vous verez qu'a mesure que vous conduirez le filet il s'eleuera et suiuera Les costez du triangle qui sont en perspectiue des lignes radiales. que si par vne autre experiance vous ostez Le filet, et qui par le trou ou il estoit attaché vous regardiez le triangle, Vous apperceurez que ces costez suiueront iustement les paralelles. A.B. et A.B. au plan geometral: et le triangle couurira toute l'espace contenue entre ces lignes. dauantage vous connoistrez que quelque longeur quelles puissent auoir, elles ne s'eleueront jamais a la hauteur des triangles: et que l'espace qui restera de ces triagles Sera toujours proportionel a son tout.

96

logne, avec privilège du Roy. F. Jollain sculpsit, Paris, n.d. On the copy we consulted, the year 1661 was marked in pencil.
From the dedication to Lebrun: "This little work is more yours than mine. It is only fitting that it return to its source, to whom I humbly present it, begging that you accept it, Monsieur, as an offering from your most humble servant and closest friend."

Plates 95, 96: Text and facing illustration pages. "Theorem 1. Whatever the distance separating the observer's eye from a triangle set up at ground level, as long as the eye is at the same level as the summit of the triangle, it will seem to extend over a parallel space infinite in length."

PLANCHE III.

fig. 29

Huret, f.

Grégoire Huret (1606–1670). Draftsman and engraver. Admitted to the Académie Royale de Peinture et de Sculpture in 1663 in recognition of the thirty-two prints in his *Théâtre de la Passion*. Portraitist of Henry IV of France, Louis XIII, Louis XIV, Anne of Austria, the Grand Condé, Mazarin, Richelieu, and Mary Stuart. Executed engravings based on works by Rubens, Simon Vouet, Sébastien Bourdon, and Daniel Dumonstier.

Optiqve de portraictvre et peintvre, en deux

parties. La premiere est la perspective pratique accomplie pour représenter les sompteueses architectures des plus superbes bâtiments en perspective par deux manières (théorie et pratique). La deuxième partie contient la perspective spéculative. . .par Grégoire Huret, desseignateur et graveur de la Maison ordinaire du Roy et de l'Académie Royale de Peinture et Sculpture. A Paris. Charles de Seray. 1670. Avec Privilège du Roy, Paris, 1670. Engravings by the author.

Huret condemns Cousin, Barbaro, Al-

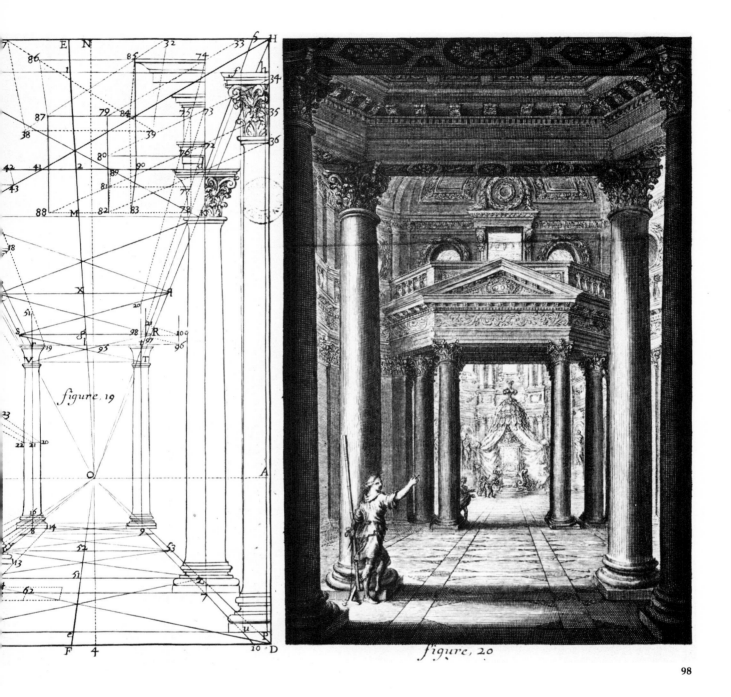

figure, 19

figure, 20

berti, Giovanni Paolo Lomazzo (author of a treatise of 1584 on painting), and Leonardo da Vinci. In the foreword, he remarks that "the lessons given by A. Bosse in the Royal Academy contain a number of errors." The second part of the text is a refutation of Desargues and Bosse.

Plate 97: Frontispiece. "In the reign of the invincible and ever-triumphant Louis XIII, Most Christian King of France and Navarre. 1670. Grégoire Huret, draftsman and engraver-in-ordinary of His Maj-

esty's residence and his Royal Academy of Fine Arts, wrote this treatise on optics, portraiture, and painting, containing both theoretical and applied perspective, together with the most interesting questions concerning portraiture hitherto proposed, with their answers."

Plate 98: Proposed scheme for a throne room.

Plate 99: Various anamorphic designs showing the distortion produced by distance and curved surfaces.

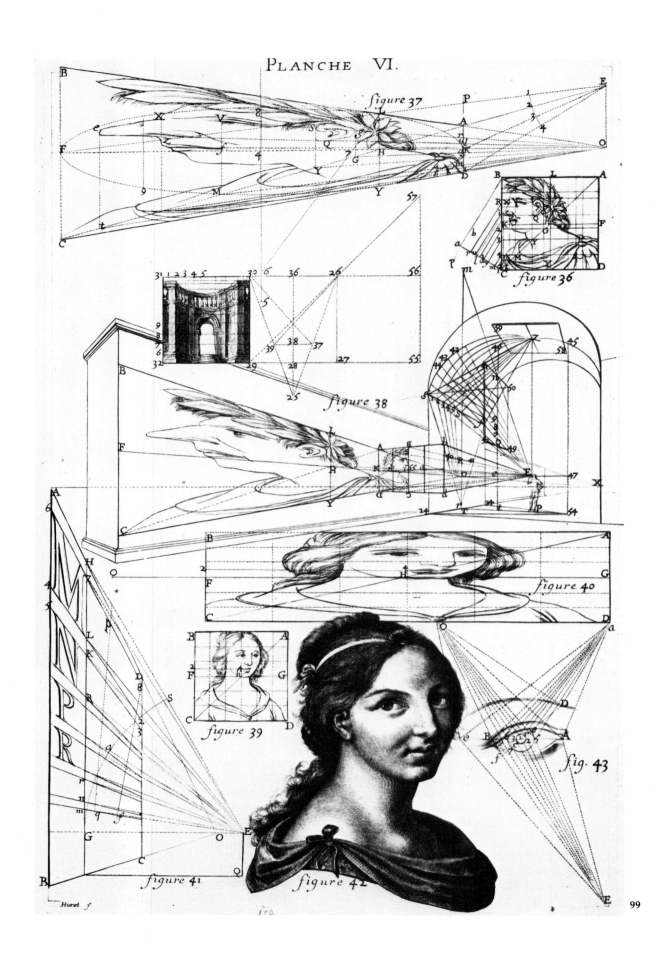

figure 37

figure 36

figure 38

figure 40

figure 39

figure 41

figure 42

fig. 43

Huret f.

PROSPETTIVIA TEORICA E PRATTICA.

PARADOSSI
PER PRATTICARE LA PROSPETTIVA SENZA SAPERLA.
E FACILITARE LA INTELIGENZA
PER NON OPERARE ALLA CIECA.

100

Giulio Troili da Spilamberto, called Il Paradosso (1613–1685). Painter and theorist from Bologna. Pupil of Francesco Gessi.

Paradossi per praticare la prospettiva senza saperla. Fiori per facilitare l'intelligenza. Frutti per non operare alla cieca. Cognitioni necessarie a pittori, scultori, architetti ed a qualunque si diletta del Disegno, dat'in luce da Giulio Troili da Spinlamberto, detto *Paradosso, pittore, dell'illustrissimo Senato di Bologna, dedicati agli illustriss. e excellentiss. S.S. li S.S. Marchesi Guido e Filippo suo figliuolo Rangoni, baroni di Pernes, S.S. di Spinlamberto, marchesi di Roca Bianca, e Gibello, co. di S. Cassano, e Cordignano, etc. A Bologna,* 1672. The illustrations are woodcuts.

In his preface, Il Paradosso claims, "I wanted to learn what neither the worthiest men nor books had offered me."

PRATTICA PER
FACILITARE LA
PROSPETTIVA
PRATTICA.
Ò DI FIGVRE.
Ò DI LINEE.

F 2

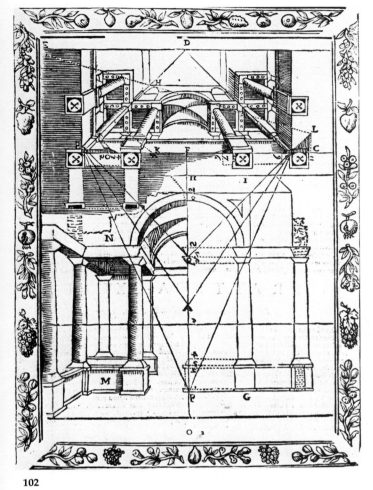

102

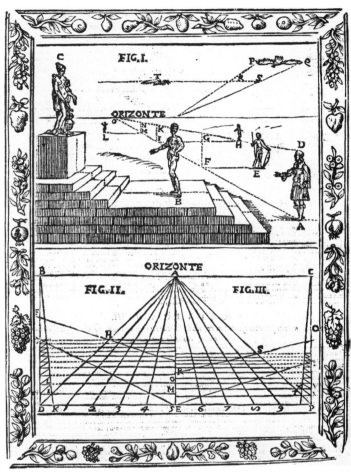

103

His sources include Vitruvius, Vincenzo Scamozzi (Italian architect andtheorist), Vignola, Serlio, Alberti, Vredeman de Vries, Barbaro, Accolti, Lorenzo Sirigatti, and "a French Jesuit priest" (Dubreuil?).

Plate 100: Frontispiece. "Theoretical and practical perspective. Paradoxes to aid beginners in perspective drawing and to prevent their working in the dark."

Plate 101: "Techniques to facilitate drawing figures and lines in perspective." Here, Il Paradosso presents his version of the old technique for copying in perspective, complete with eyepiece and screen.

Plate 102: Structure seen from below and from the front.

Plate 103: Position of figures in relation to the horizon.

120

Samuel van Hoogstraeten (1627–1678).
Dutch artist specializing in genre paint-
ing, portraiture, architectural fantasies,
and religious subjects. Student of Rem-
brandt. Traveled to Rome, Vienna, and
London. In London's National Gallery,
there is a perspective cabinet by Van
Hoogstraeten: putting an eye to one of the
two peepholes cut into the sides of this
rectangular box, the observer feels he is
looking into the fully three-dimensional
interior of a Dutch house. The inside walls
of the box are cleverly painted with views
in anamorphic perspective, and the illu-
sion is astonishingly vivid. Perspective
cabinets were popular in the Netherlands
in the late seventeenth century.
In 1641, the first edition of Van Hoogstrae-
ten's *Inleyding tot de hooge schoole der schil-
derkonst* was published. An "introduction
to the advanced school of painting," the
work included exercises and instruction in
perspective rendering. It was republished
in 1678, the year of the artist's death.

*Inleyding tot de hooge schoole der schilder-
konst: anders de Zichtbaere Werelt. Verdeelt*

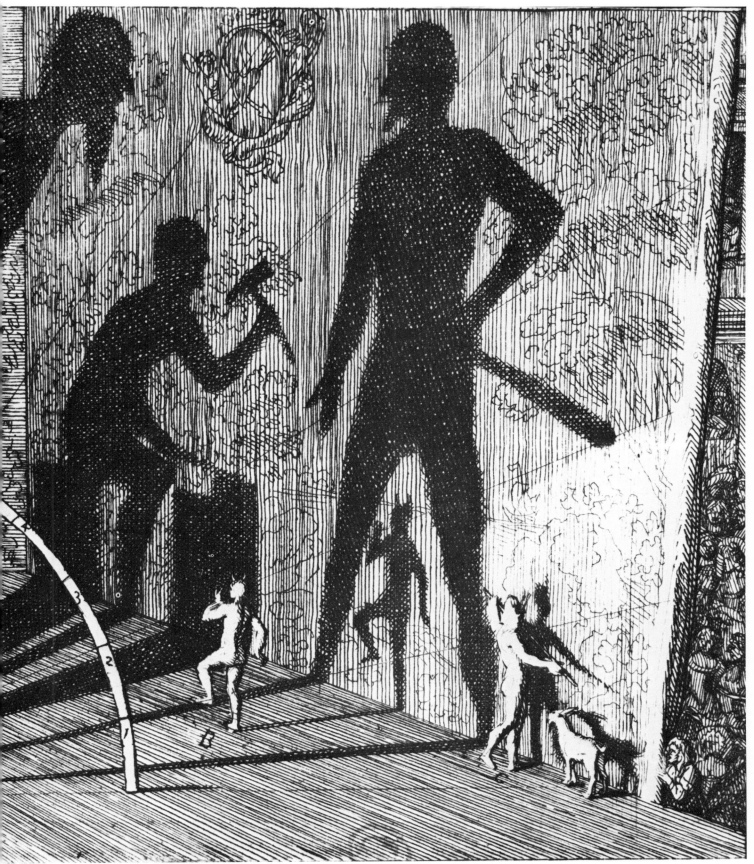

ZESTE HOOFTDEEL.

Van de schaduwen der Zonne, en haere streekvallen.

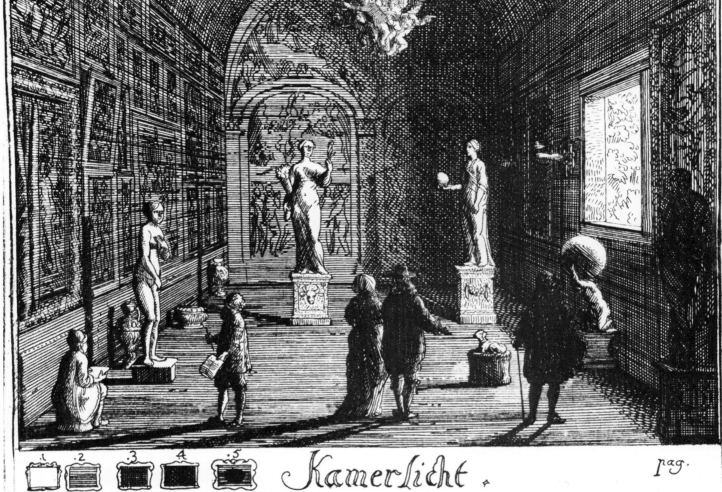

Kamerlicht

pag.

107

in negen Leerwinkels, yder bestiert door eene der zanggodinnen. Ten hoogsten noodzakelijk, tot onderwijs, voor alle die deeze edele, vrye, en hooge Konst oeffenen, of met yver zoeken to leeren, of anders eenigzins beminnen. Beschreven door Samuel van Hoogstraeten. Tot Rotterdam. by François van Hoogstraeten, Boekverkooper, Rotterdam, 1678.

Plate 104: Shadows cast against a wall (Book 7: ''Melpomene'').

105: ''Part Six. On the shadows cast by the sun, and its rays'' (Book 7: ''Melpomene'').

Plate 106: Shadows cast when the sun is shining from the side (Book 7: ''Melpomene'').

Plate 107: ''Interior light'' (Book 7: ''Melpomene'').

Figura 70.

108

Andrea Pozzo (1642–1709). Clergyman, painter, architect, theorist. He executed *trompe l'oeil* paintings for many Italian churches, his greatest and best known being those for S. Ignazio in Rome. At the request of the Prince of Liechtenstein, he went to Vienna, where he rebuilt and decorated the Universitätskirche (1703–4) and provided paintings for the Liechtenstein Palace.

Prospettiva de' Pittori e Architetti d'Andrea Pozzo, della Compania di Giesù. Parte prima. In cui s'insegna il modo più sbrigato di mettere in prospettiva tutti i disegni d'Architettura. In Roma MDCXCIII...Con

Figura 91

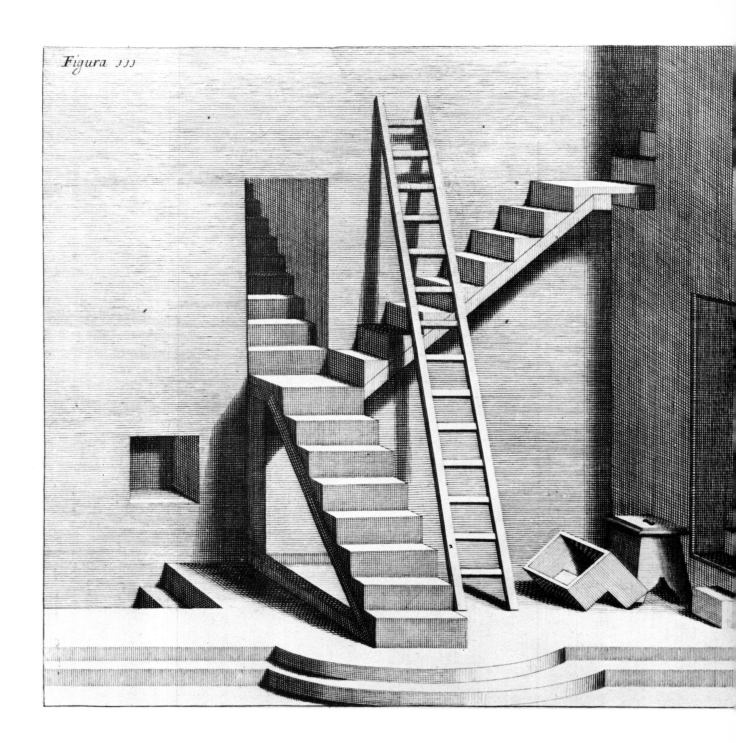

Figura III

licenza de' Superiori, Rome, 1693. Dedicated to the ''Sacra Cesarea Maesta' di Leopoldo Austriaco Imperadore.''
Parte Seconda. In Roma. L'anno santo 1700. Rome, 1700. Dedicated to the ''Sacra Real Maesta di Giuseppe Primo, re dei Romani e d'Ungaria, arciduco d'Austria.''
In the preface, Pozzo remarks, ''There are painters who say that one can do without perspective when drawing figures; but it is indispensable for color, shadow, and light.''

Plates 108, 109: Preparatory perspective profile and detailed elevation for a theatrical setting of the *Marriage at Cana,* painted in the church of Il Gesù in Rome in 1685.

110

Plate 110: Composition with stairs, a ladder, passageways, and pieces of furniture: perspective drawing, side elevation, and plan.

Plates 111, 112: Preparatory perspective sketch, plan, and detailed elevation of a monument.

112

18TH CENTURY

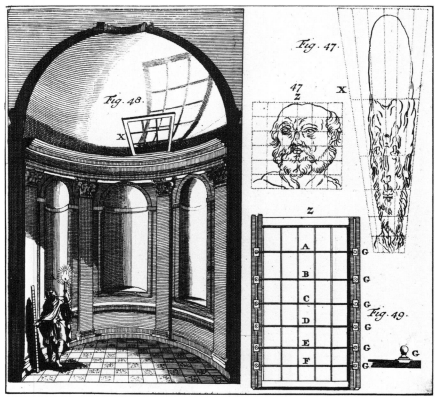

Bernard Lamy (1640–1715). Priest of the Oratory of Jesus. Author of many books on a variety of subjects, including *Nouvelles réflexions sur l'art poétique* (1668); *De l'art de parler* (1675); *Traitez de méchanique, de l'équilibre des solides et des liqueurs* (1679); *Traité de la grandeur en général* (1680); *Entretiens sur les sciences* (1683); *Les élémens de géométrie* (1685); *Apparatus ad Biblia Sacra* (1687); *Démonstration de la vérité et de la sainteté de la morale chrétienne* (1688); *Harmonia sive concordia quatuor evangelistarum* (1689); *Traité historique de l'ancienne Pâque des juifs* (1693); and *De Templo hierosolymitano libri septem* (1697).

Traité de perspective, où sont contenus les fondemens de la peinture...par le R.P. Bernard Lamy...Paris, chez Anisson, directeur de l'Imprimerie royale, Paris, 1701. New edition: Amsterdam, 1734.

English translation: *Perspective made easie: or, the Art of representing all manner of objects as they appear to the eye in all scituations. Containing the elements of designing and painting...Written originally in French by Bernard Lamy...and faithfully translated into English by an officer of Her Majesties' Ordnance,* London, W. Taylor 1710.

The first edition was illustrated with woodcuts, a later edition of 1734 with copperplate engravings.

"My only intention in revising this treatise is to elucidate the Holy Scriptures with greater success. I wrote it more than thirty years ago. I resumed work on it because of an important project now being planned, namely, a description of the Temple in Jerusalem." Bernard Lamy showed that painting is perfect only when the artist respects the laws of perspective. Every painting is an exercise in perspective. "A mathematician who is neither painter nor draftsman, can nevertheless try his hand at painting."

"Orthographic projection shows a building according to its lengths, thicknesses, heights, and depths. Generally speaking, it shows everything that can be seen from a single vantage point, assuming the observer to be infinitely distant, or larger than the object."

Plate 113: Shadows cast on a vault, and an anamorphic projection.

Plate 114: Prisoner and sphere.

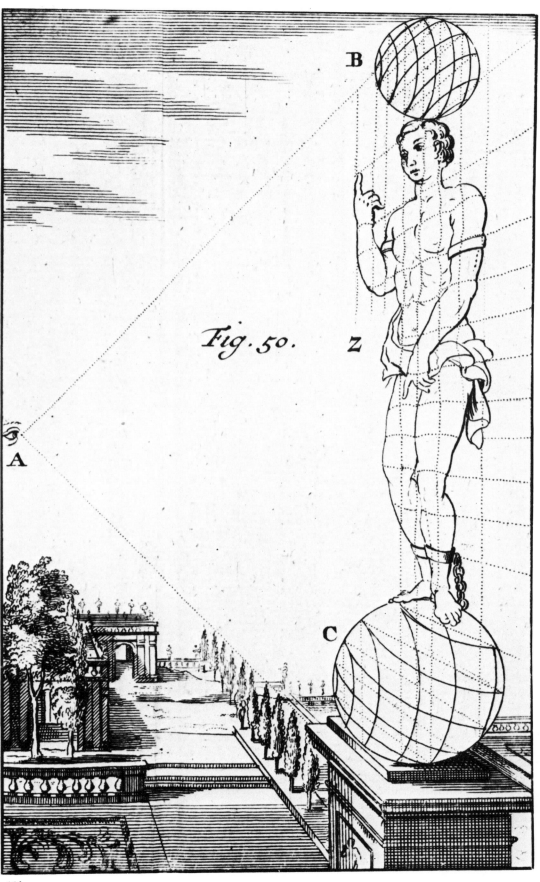

Fig. 50.

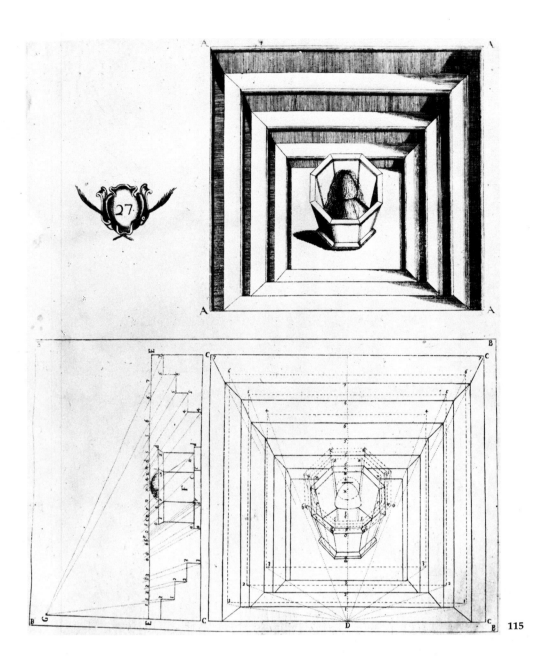

132

Paolo Amato (1634–1714). Clergyman, architect, draftsman, engraver. Engineer and architect of the Senate of the city of Palermo, where he constructed altars, tombs, and an opera house and was also in charge of decorations for festivals. He began to publish his *Nuova pratica di prospettiva* in 1714, but ill health prevented him from continuing, and it was brought out after his death under the supervision of a colleague.

La nuova pratica di prospettiva, nella quale si spiegano alcune nuove opinioni e la Regola universale di Disegnare in qualunque superficie qualsivoglia oggetto, opera utile e necessaria a pittori, architetti, scultori et professori di disegno, del sacerdote D.D. Paolo Amato, cittadino Palermitano, Ingegnere ed architetto dell'Excellentissimo Senato Palermitano, dedicata alla venerabile congregazione de sacerdotti sotto titolo della Carita di S. Pietro. In Palermo, per Vincenzo Toscano, e Onofrio Gramignani nel 1714, con licenza dei Superiori, Palermo, 1714–33. New edition: Palermo, 1736.

Plate 115: View, cross section, and plan of a fountain within a tiered structure.

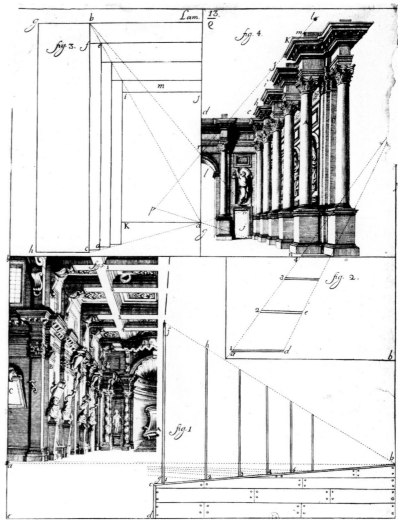

Antonio Acisclo Palomino de Castro y Velasco (c. 1653–1726). Spanish painter, art historian, and theorist. After studying theology in Cordova, he worked with Juan de Valdés Leal, Juan Carreño de Miranda, and Claudio Coello.

El Museo pictorico y escala optica. Tomo I: Theorica de la pintura, en que se describe su origen, essencia, especies y qualidades, con todos los demàs accidentes que la enriquezen è ilustran. Y se prueban, con demonstraciones mathematicas y filosoficas, sus mas radicales fundamentos. Dedicale a la Catolica, Sacra, Real Magestad de la Reyna nuestra Señora, Doña Isabel Farnesio, dignissima esposa de nuestro Catolico Monarca Don Felipe Quinto. Por mano del excelentissimo señor Marqués de Santa-Cruz, Mayordomo Mayor de Su Magestad: su mas Humilde Criado D. Antonio Palomino de Castro y Velasco. Con Privilegio. En Madrid ... Año 1715. Tomo II: Pratica de la pintura ... Y de la perspectiva commun, la de Techos, Angulos, Teatros y Monumentos de Perspectiva, y otras cosas ... Su mas Humilde criado Don Antonio Palomino Velasco, Pintor de Camara de su Magestad. Con Privilegio. En Madrid, 1724. Tomo III: El parnaso Español pintoresco laureado ... Madrid. 1724. Three volumes, Madrid, 1715–24.

The third volume was translated into English in 1744, into French in 1749, and into German (by Anton Raphael Mengs) in 1779.

This work claims to be a summa of theoretical, practical, historical, and esthetic knowledge.

In the second volume, Palomino remarks, "But there are some artists so limited (better described as mechanical) that to speak to them theoretically is the same as to speak to them in Arabic." As his theoretical sources, Palomino cites Leonardo da Vinci, Federico Zuccaro, Giovanni Paolo Lomazzo, "and others." Proverb: Practice without theory is like a body without a soul. Theory without practice is like a soul without a body.

Plate 116: An illustration regarding the rendering of theaters, altars, and monuments. Although signed by Palomino, this plate is an exact copy of the design for an antechamber in Andrea Pozzo's *Prospettiva dei pittori e architetti* (Rome 1693–1700).

116

117

Brook Taylor (1685-1731). English geometer and mathematician. First became known to the scientific world in 1708 through a study on the center of oscillation of a body. In 1712, admitted to the Royal Society, where he presented works on capillarity, the vibration of cords, magnetism, and the thermometer. Engaged in a series of disputes with Johann Bernoulli over a number of mathematical problems. In later years, he turned to philosophical and religious thought. His best-known work, *Methodus incrementorum directa et inversa*, was published in London in 1715, the same year as his work on perspective, *Linear Perspective*.

Nouveau Principes de la perspective linéaire, traduction de deux ouvrages, l'un anglois, du Dr. Brook Taylor, l'autre, latin, de M. Patrice Murdoch, avec un essai sur le mélange des couleurs, par Newton, A Amsterdam et se vend à Lyon chez Jean-Marie Bruyset, imprimeur libraire, rue Mercière, au Soleil, Lyons, 1759 (includes a translation into French of *Linear Perspective*).

Brook Taylor notes in the preface that if everything hitherto written on this subject is long and tedious, it is because these works are more concerned with drawing technique than the principles of geometry. He adds, "The quickest and surest way to become proficient in an art form is not to leaf through large quantities of examples drawn by others, but to have a firm grip on the principles involved and to apply them to the various cases that may arise."

Plate 117: Shadows and reflections.

Johann Jacob Schübler (d. 1741).
Mathematician and architecture theorist
from Nuremberg. Author of *Sciagraphia
artis tignariae* (1736).

*Perspectiva...Das ist: Kurtze und leichte
verfassung der practicabelsten regul, zur
perspectivischen Zeichnungskunst...von
Johann Jacob Schübler*, Nuremberg,
1719–20.

Plate 118: How to render a circular stair-
case, artificially lit from above, with the
light pouring out the door (above). An
artist's studio at night, artificially lit,
showing how the shadows of different ob-
jects should be rendered (below).

Plate 119: Example of an unusual kind of
perspective view.

TAB. 23.

120

Jean Courtonne (1672-1739). Architect, draftsman. Built the Hôtel de Noirmoutier and the Hôtel de Matignon in Paris. Published *L'Architecture moderne*, with 150 illustrations, in 1728.

Traité de la Perspective Pratique avec des remarques sur l'architecture; suivies de quelques édifices considérables mis en perspective, et de l'invention de l'auteur, ouvrage très-utile aux amateurs de l'Architecture et de la Peinture, par le Sieur Courtonne, architecte, dédié à Monseigneur le Duc d'Antin. A Paris, chez Jacques Vincent, 1725, avec approbation et privilège du Roy, Paris, 1725.

Dedication: "My Lord, may perspective, which has all but vanished from the sacred hierarchy of the fine arts, find in Your Grace the same protection you have accorded her sisters with such distinction."

Plate 120: Composition with light and shade. Shadows cast by a cube.

Fig. XII

121

Paul Heinecken (1680-1746). Draftsman and theorist from Lübeck.

Lucidum prospectivae Speculum...ein Heller Spiegel der Perspective...Wozu noch beygefügt sind Achtzehen Plafonds oder decken-Stücke von diversen Sorten. Den Liebhabern und Anfangern dieser schönen Science zum Besten aufgestellt von Paul Heinecken, Mahlern in Lübeck. Augsburg. In Verlag Jerem. Wolffs....An. 1727, Augsburg, 1727. Republished Augsburg, 1753. Engravings by Georg David Nessenthaler.

This is one of the most beautiful, comprehensive, "monumental" treatises written in the eighteenth century.

Plate 121: "An eight-sided star with light source and cast shadows."

Plate 122: "How an iron rod and a stick cast their shadows on a canted wall."

Plate 123: "How a stick lying across a [half-cylinder] next to a rod or nail casts shadows into the curved surface below."

Plate 124: "How to render correctly the shadows cast by a cross standing on a star and the reflection in a polished floor and mirror."

Plate 125: "How two open doors can be sketched in perspective."

Plate 126: "A large open staircase rises upward in perspective."

Plate 127: "A Catholic double-confessional."

Plate 128: "A ceiling painting with Doric columns."

122

123

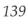

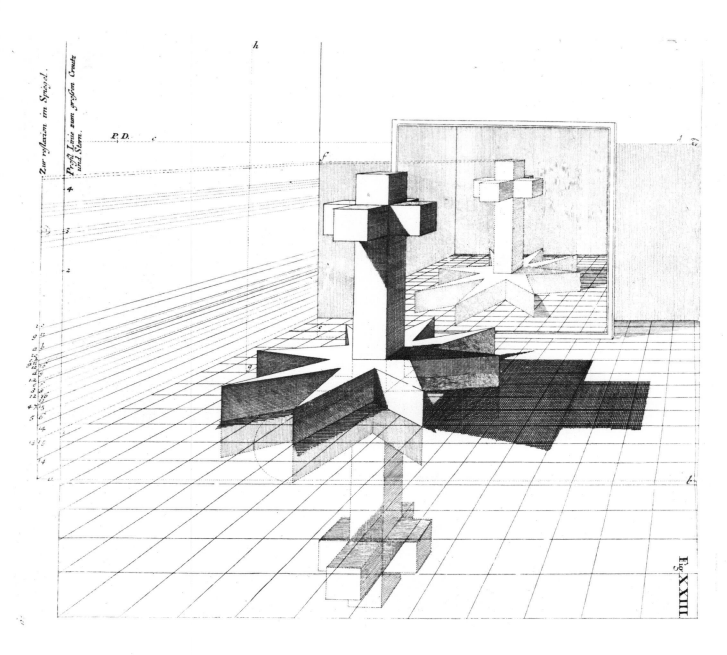

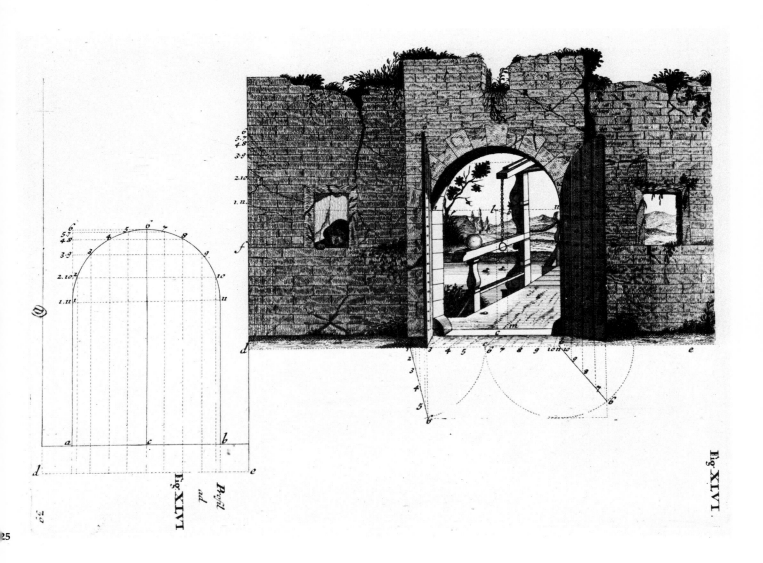

Fig. XLVI

Fig. LI

126

127

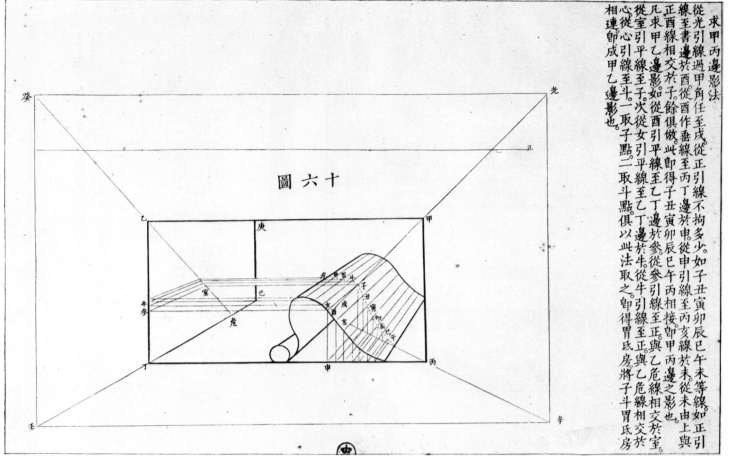

圖六十

Nien Hsi-yao (n.d.). Minister in the imperial house of China, Secretary of Customs, director of the porcelain works in K'ing-tö-chen. Student of Giuseppe Castiglione in painting. Author of various works on trigonometry.

Giuseppe Castiglione (1688-1766). Jesuit, painter. Arrived in China in 1715 and became first painter to the emperor, working in silk, glass, porcelain, and enamels. Erected Baroque pavilions at the Summer Palace. Died in Peking.

Authors of *Shih-hsüeh*, a Chinese adaptation of Andrea Pozzo's *Prospettiva dei pittori e architetti* (Rome, 1693–1700).

Shih-hsüeh, 1729. Second edition: 1735 (illustrated).

As Cécile and Michel Beurdeley note in *Castiglione, peintre, jésuite à la cour de Chine* (1971), Nien Hsi-yao writes in his preface to *Shih-hsüeh* that he studied the subtleties of Chinese painting—especially creating the illusion of three dimensions with shadows—under the guidance of Lang Che-Ning (Giuseppe Castiglione).

Plate 129: Unrolled cylinder in perspective.

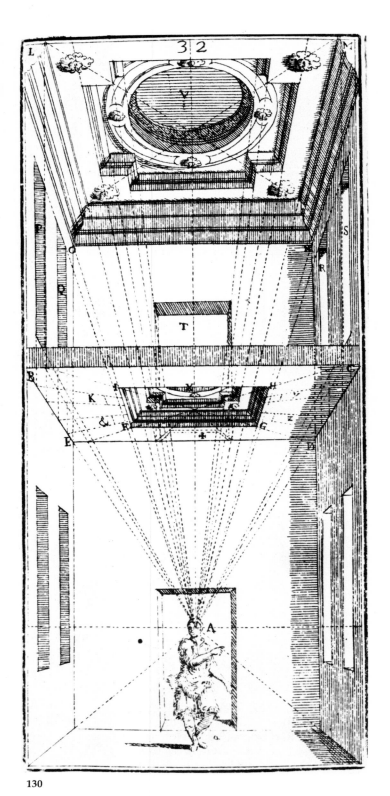

Ferdinando Galli da Bibiena (1657-1743).
Painter, architect, draftsman, stage designer. Student of Carlo Cignani. Worked in Vienna and in Munich as well as in major Italian cities. Author of: *Varie opere di prospettiva* (1703–8); *L'Architettura civile, preparata sú la geometria e ridotta alle Prospettive* (1711).

Direzioni ai giovani studenti del disegno dell'architettura civile e della prospettiva teorica, raccolte da Ferdinando Galli Bibiena, citadino bolognese, Academico Clementino, Architetto primario e Pittore di Camera e feste teatrali. Di S.M. CES., E CAT. divise en cinque parti. Tome Secundo, dedicato dall'autore a S. Petronio, Vescovo e principal Protettore di Bologna. In Bologna. Nelle Stamperia di Lelio dalla Volpe. 1731. Con licenza de' Superiori, Bologna, 1731.
The work is divided into five sections:
I. General definitions of perspective.
II. Perspective techniques for figure painters.
III. Perspective techniques for stage designers.

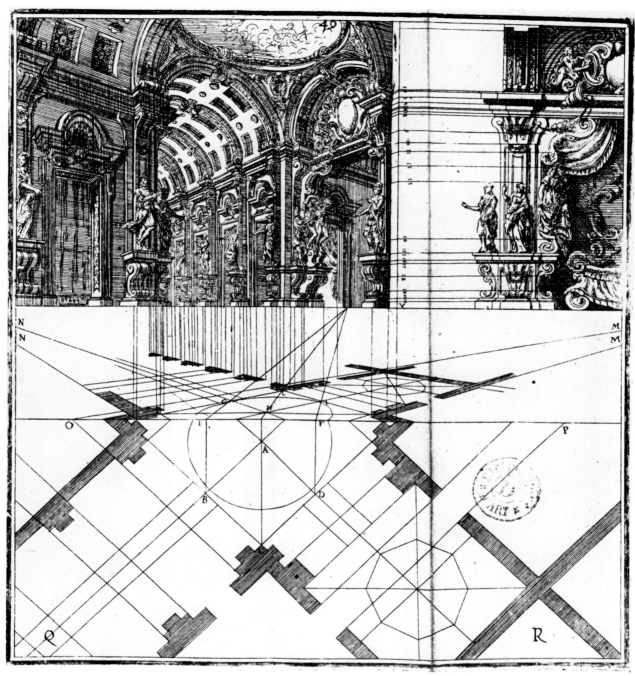

IV. Concerning directions of shadows and lights.

V. Concerning the mechanics and art of moving and transporting heavy weights.

Sources for perspective: Barbaro, Dürer, Vignola, Lorenzo Sirigatti, Accolti, Nicéron, Chiaramonte, Il Paradosso; for painting: Dürer, Lomazzo, Accolti, Alberti, Leonardo da Vinci; for mechanics: Guido Ubaldo, Vitruvius, and Niccolò Tartaglia.

Plate 130: Two-story structure in perspective.

Plate 131: Perspective view and plan of a Baroque church.

Giovanni Francesco Costa (1711-72). Painter, architect, engineer, and stage designer. The Teatro San Benedetto (later Rossini) in Venice was built according to his plans (1755–73). Admitted to the Academy of Venice in 1766. Author of *Delizie del Fiume Brenta* (1750–56), a delightful collection of scenes along the Brenta Canal, with 56 plates, one of which shows a *camera ottica* in use (a box with mirrors to aid the artist in creating "scientifically" exact views).

Elementi di prospettiva per uso degli ar-

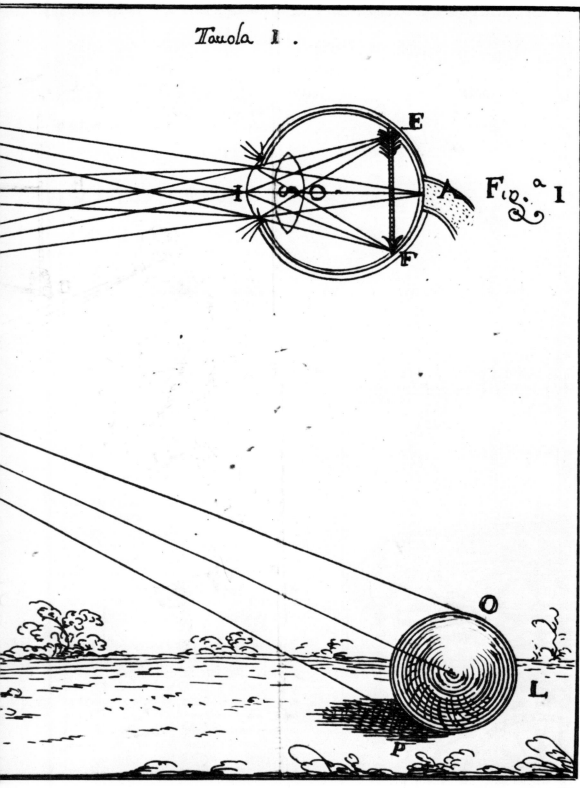

Tauola I.

F

Fig.ª I

I

F

O

L

P

chitetti e pittori, esposti da Gianfrancesco Costa, architetto e pittore veneziano, in Venezia, 1747. Con licenza de Superiori, Venice, 1747.

Costa's sources are still Euclid and Ptolemy; his mechanical aids still the mirror, compass, square, and plumb-line. But now the observer depicted is a gentleman who has stepped out of the world of eighteenth-century Venice.

Plate 132. [Without caption.]

Soubeyran, Inv.　　　　　　　　J. Ingram, Sculp.

TRAITÉ
DE
PERSPECTIVE
A L'USAGE
DES ARTISTES.

❖❖❖❖❖❖❖❖❖❖❖❖❖❖❖❖❖❖❖❖❖❖❖

SECONDE PARTIE.
Contenant la pratique de la Perspective.

LEÇON PREMIERE.
Faire des carreaux dans un tableau.

S I l'on suppose les parties égales G E, E S, S H, HD PLANCH:
pour la grandeur des carreaux proposés, de ces points XXIII.
G E S H D tirez au point de vûe. D'un point quelcon-
que comme G, tirez au point de distance K la diago-
nale G M qui coupera les fuyantes au point de vûe; & des sections
I ij

133

Leçon XVII.

Planche XXX

A B C

AB egale à BC

134

Edme-Sébastien Jeaurat (1724-1803). As-
tronomer. At the age of twenty, he was
awarded a prize in drawing from the
Académie de Peinture. Professor of
mathematics at the Ecole Militaire in 1753.
Admitted to the Académie des Sciences in
1763. His *Nouvelles Tables de Jupiter* was
published in 1766. Invented a double-
image telescope in 1778.

Traité de Perspective à l'usage des artistes,
où l'on démontre géométriquement toutes les
pratiques de cette Science, & où l'on en-
seigne, selon la Méthode de M. Le Clerc, à
mettre toutes sortes d'objets en perspective,
leur réverbération dans l'eau, & leurs
ombres, tant au soleil qu'au flambeau. Par
M. Edme-Sebastien Jeaurat, Ingénieur-
Géographe du Roi. A Paris, Quai des Au-
gustins, Chez Charles-Antoine Jombert,
Libraire du Roi pour l'Artillerie & le Génie,
Paris, 1750.
''It is true that Perspective cannot afford
a painter elegance of design; there are
other rules for grasping the nature of
things. But this science will help him
arrange his figures; and aerial perspec-
tive, by means of seductive shadings,
can produce beautiful and startling ef-
fects on a flat surface. If the shadings are

LEÇON LXXVII.

Fronton dirigé au point de vûe.

PLANCH. LXXIX. La diſtance propoſée étant portée perpendiculairement au-deſſus du point de vûe, comme en A, & horiſontalement comme en Q, il faudra du point de diſtance A, comme centre & de l'ouverture A Q décrire l'arc Q D, puis faiſant B C égale à C D, les points B, D feront les points évanouiſſans du fronton. Ainſi du profil géométral N M on élevera des perpendiculaires N E, M G. Du point de vûe, & par le même profil, on menera les lignes T O, V S. D'un point quelconque O, pris ſuivant la grandeur qu'on ſe propoſe de donner au fronton, on tirera au point de diſtance Q la diagonale O P. Des grandeurs géométrales N, K, & par le point de vûe, on menera encore des lignes qui, rencontrant la diagonale O P, & abaiſſées perpendiculairement comme P S, détermineront le profil perſpectif O S (Leçon LVII). Des points O, R, on tirera au point B, ce qui donnera le profil E F. Du point F, on menera la parallele F G; on fera les grandeurs G, H égales aux grandeurs L, M, ce qui achevera le profil E F H, duquel on menera par le point B les lignes H Y, & on tirera au point D, les lignes E T, H X. Enfin du point T, & par l'autre point de diſtance, pris dans l'horiſon, on menera la diagonale T X, qui donnera le moyen de tracer le dernier profil T Y cherché.

PLANCH. LXXX. On voit ſur la Planche LXXX, vis-à-vis, l'application des regles expliquées dans cette Leçon à une compoſition d'Architecture, décorée d'un Ordre Dorique & ſurmontée d'un fronton triangulaire.

135

incorrect, even the most fastidious perspectivist will end up with the nearer sections seeming farther away and the more distant sections seeming closer."

With drawings by Soubeyran, engraved by Ingram. Tailpieces by Babel.

Plate 133: Title page. Cherubs studying geometry and perspective.

Plate 134: Perspective view and plan of a mosaic.

Plate 135: "Pediment positioned in perspective." This plate teaches the reader how to determine vanishing points geometrically as a preliminary step for drawing in perspective. By a series of perpendiculars and arcs, *B* and *D* are established as the vanishing points of the pediment to be drawn; all other lines are then drawn in proportion to both the lengths they represent and the perspective lines dictated by the vanishing points. This lesson demonstrates that even a complex object can be rendered in perspective with the help of only a few simple mathematical guidelines.

Plate 136: Building with Doric decoration, topped with a triangular pediment.

ENTABLEMENT DORIQVE AVEC DES MODILLONS ET TRIGLIFS VEUS DE L'ANGLE.

Le Plan geometral A, avec la distribution des modillons étant [...] fait et mis en perspective il faut elever la ligne A C, sur laquelle il faut mettre en mesure tous les membres de l'Entablement et du Chapiteau Composé et tirer des lignes de toutes les sections sur A C, au point de vue sur la ligne B D, centre de la Colonne; Cette Leçon se fait comme celle du Chapiteau et Entablement Corinthe sur l'angle, elle n'est differente qu'en ce que l'entablement est sur le chapiteau et que l'Entablement et le chapiteau sont separés, les modillons sous la face ou Couronne doivent estre à plomb sur leurs plans perspectives il ne faut que regarder la Figure cy dessus pour en apprendre la Construction.

Louis Bretez (n.d.). Designer specializing in architecture and decorative motifs. Worked on Lucas' Grand Plan de Paris, called the Plan de Turgot (1739).

La perspective practique de l'architecture, contenant par leçons une manière nouvelle, courte et aisée pour représenter en perspective les ordonnances d'architecture et les places fortifiées, ouvrage très-utile aux peintres, architectes, ingénieurs et autres dessinateurs, par Louis Bretez. A Paris, rue Dauphine, chez Charles-Antoine Jombert, libraire du Roy pour l'Artillerie et le Génie, à l'Image de Notre-Dame. Avec approbation et privilège du Roy, Paris, 1706. Republished, 1751.

"This science may be called the mirror of Nature, for it shows objects as they really are."

"It is no mean feat to position objects correctly in art and to place them at a distance that makes them pleasant to look at. This science may be the province of optics, but experience and good taste are of greater value than all the teachers put together."

Although it includes a chapter on the use of perspective in stage design, this work addresses itself primarily to painters. Civil and military architects would also have found it particularly useful.

Plate 137: "Doric entablature with modillions and triglyphs viewed at an angle."

Plate 138: Capital. "One need only examine the above figure to learn how to construct it."

Plate 139: Perspective view of a staircase. Bretez shows several of these, this one being the most complex.

Plate 140: "Bird's-eye view of a hexagonal fortification." The author adds that the shading scale above the picture need not be included in the drawing: "They can be made separately on a board or on the wall of your room."

A. Point de Veüe.
B. Point airal ou Point Doyseau.
C. Point ateral.
D. Plan Perspective.
BAC. Axe de la Veüe.
BE. Ligne Accidentalle.
CF. Ligne Accidentalle.

Horisont

F

A

D

C

E

139

Place Mediocre Place

toises 100 90 80 70 60 50 40 30 20 10

300
270
240
210
180
150
120
90
60
30

10 20 30 40 50 60

270
240
210
180
150
120
90
60
30

BJ Scotin

EXAGONE FORTIFIÉ, VEÜ EN PERSPECTIVE A VOLS DOISSEAUX

Le plan de cette place se fait perspectiue comme celuy du pentagone cy deuant, sur les angles duquel il faut eleuer des perpendiculaires, et prendre les mesures des hauteurs des profils sur l'echelle de degradation, quil faut porter sur les lignes eleuées, puis tirer des lignes qui formeront le pourtour de la place; l'echelle de degradation du dessein cy dessus, et celle de la leçon precedente ne fuyent point aux memes points de veüe que les desseins, ce qui fait connoistre quil n'est pas necessaire quelles soyent dans les tableaux, on peut les faire separement sur vne planche, ou sur le mur du cabinet ou l'on trauaille.

140

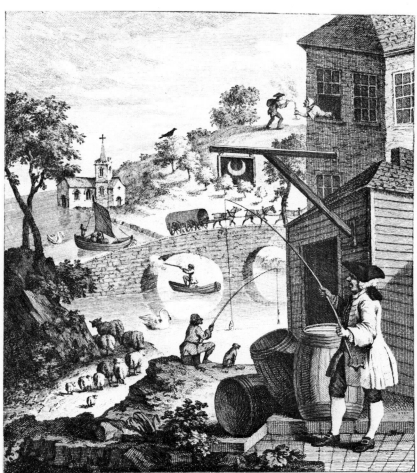

141

John Joshua Kirby (1716-1774). Painter, draftsman, engraver, watercolorist. He was encouraged by Thomas Gainsborough to paint landscapes. In 1748, he published an album of landscape etchings. Professor of architectural design to the Prince of Wales, who later assigned him to work on the palace at Kew Gardens. Member of the Free Society and the Society of Artists, where exhibitions of his work were held from 1761 to 1771.

Dr. Brook Taylor's method of perspective made easy both in theory and practice, in two books being an attempt to make the art of Perspective easy and familiar to adapt it intirely to the Arts of Design and to make it an entertaining study to any gentleman who shall chuse so polite an amusement, by Joshua Kirby, painter, illustrated with fifty copper plates, most of which are engraved by the author, 2nd ed., Ipswich, 1755. The first edition was published in London by R. and J. Dodsley in 1754.

Kirby sees Vignola and Samuel Marolois as the source for all works on perspective, with the exception of those by Dr. Taylor and a Mr. Hamilton. Also mentioned are Vredeman de Vries, Pozzo, the "Jesuit method" (Dubreuil?) and Lamy.

William Hogarth (1697-1764), painter, engraver, and illustrator of the works of such authors as Samuel Butler, Henry Fielding, Molière, and Cervantes, designed the frontispiece for Kirby's book. Hogarth was himself author of *The Analysis of Beauty,* the first treatise on aesthetics to emphasize formal problems.

Plate 141: Frontispiece, by William Hogarth. The caption reads, "Whoever makes a design without the knowledge of Perspective, will be liable to such Absurdities as are shown in this Frontispiece." Engraved by Luke Sullivan.

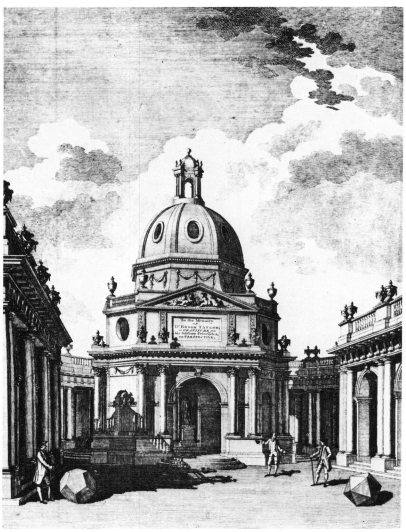

142

Thomas Malton (1726-1801). Draftsman and engraver. Professor of perspective in Dublin around 1785.

A compleat treatise on perspective, in theory and practice, on the true principles of Dr. Brook Taylor, made clear in theory, by various moveable schemes and diagrams; and reduced to practice in the most familiar and intelligent manner, showing how to delineate all kinds of regular objects, by rule. The theory and projection of shadows, by sun-shine, and by candle-light, the effects of reflected light on objects; their reflected images on the surface of water and on polished plane surfaces, in all positions. The whole explicitly treated and illustrated in a great variety of familiar examples, in four books, embellished with an elegant frontispiece and forty-eight plates, containing diagrams, views and original designs, in architecture... engraved by the author Thomas Malton, London, 1774. Second edition: London, 1779.

The work is dedicated to the president and members of the Royal Academy and addresses itself to "young students." "The neglect of the perspective amongst the rising artists is much to be lamented." Malton adds that "the principles given by Dr. Brook Taylor are sufficient for any purpose."

Plate 142: Frontispiece. "To the Memory of Dr. Brook Taylor in gratitude for his sublime Principles on Perspective."

Plate 143: "Representation of another well-known building, the Royal Hospital of Invalids . . . at Chelsea."

Plate 144: Representation of conical sections from various points of view.

Plate 145: "Representation of a staircase, internal; showing the descending stairs, direct."

Plate 146: "Of reflected light and of reflected images of objects, on water, and polished plane surfaces."

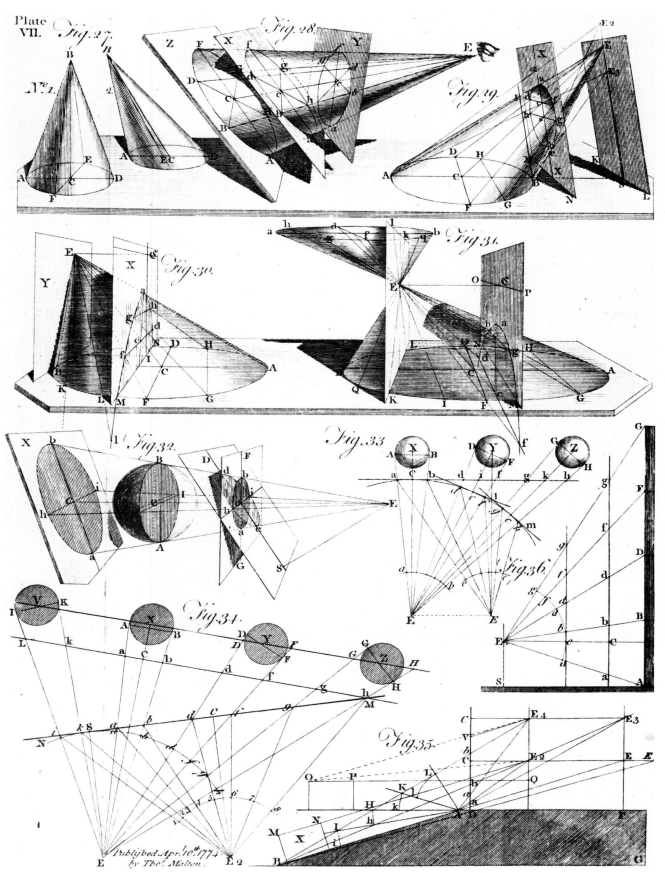

Plate VII.

Fig. 27. Fig. 28. Fig. 29. Fig. 30. Fig. 31. Fig. 32. Fig. 33. Fig. 34. Fig. 35. Fig. 36.

Published Apr. 10th 1774.
by Thos. Malton.

144

Plate XLVIII

Fig. 47.

Fig. 48.

48

Fig. 49.

146

Fig. 53.

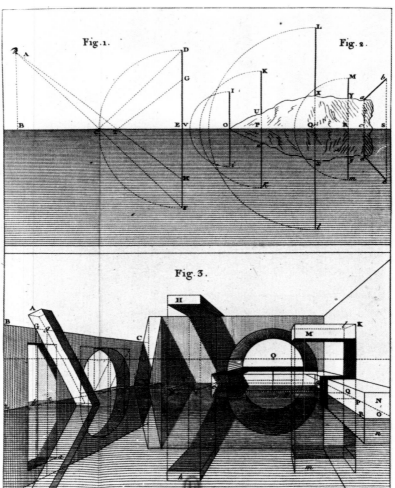

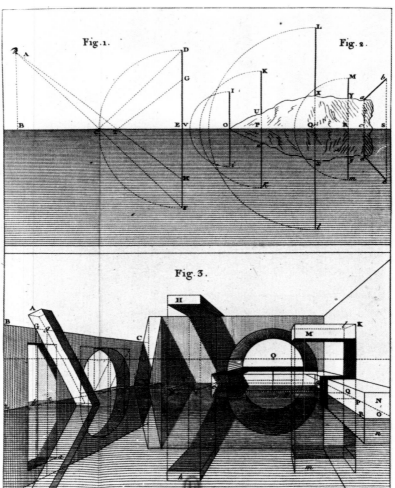

147

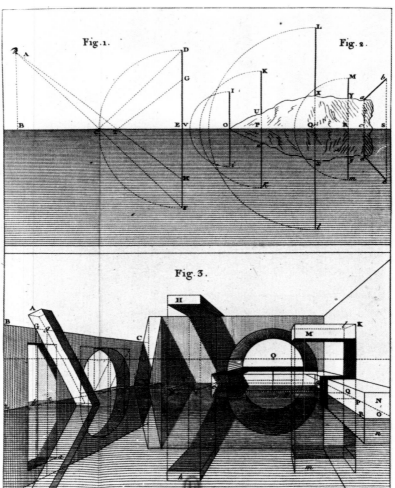

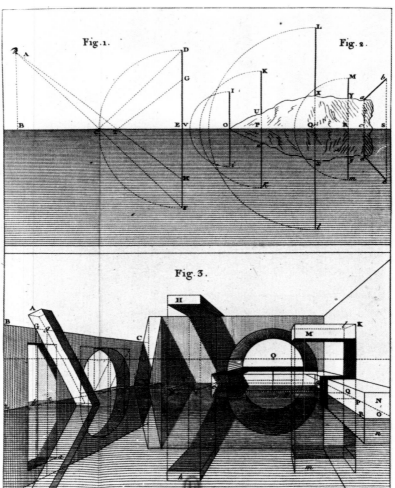

Pierre-Henri de Valenciennes (1750-1819). Painter, professor of perspective, pupil of Gabriel-François Doyen. Traveled to Italy, Spain, England, Germany, Greece, Egypt, and the Middle East. Admitted to the Académie Royale de Peinture on July 18, 1789.

Elémens de perspective pratique à l'usage des artistes, suivis de Réflexions et conseils à un élève sur la peinture et particulièrement sur le genre du paysage, par P.H. Valenciennes, peintre, de la Société Philotechnique, de celle libre des Sciences et Arts de Paris. A Paris chez l'auteur. An VIII (1800), Paris, 1800. Plates engraved by Delettre.

Valenciennes describes a meeting with Joseph Vernet as a young artist, fresh from a trip to Rome, who was confident of his knowledge of perspective. " 'I see quite clearly,' Vernet told me, 'that you have learned perspective; but I also see that you do not *know* it. Do not be alarmed,' he added, seeing my surprise, 'you know enough about it for me to demonstrate it to you in a single lesson.' And he proceeded to do so by teaching me how to position distance points.''

"About six years ago, someone in England devised an ingenious way to present an entire country scene or the whole of a city without in any way transgressing the laws of perspective. Mr. Barker [Robert Barker, its inventor] called it the Panorama.... This new approach, which has hitherto been absent from art, could prove to be a valuable contribution to knowledge."

Plate 147: Volumes, shadows, and light, as reflected in water.

Plate 148: Determination of positional values. This plate is quite similar to one of Dubreuil's. (See Plate 81.)

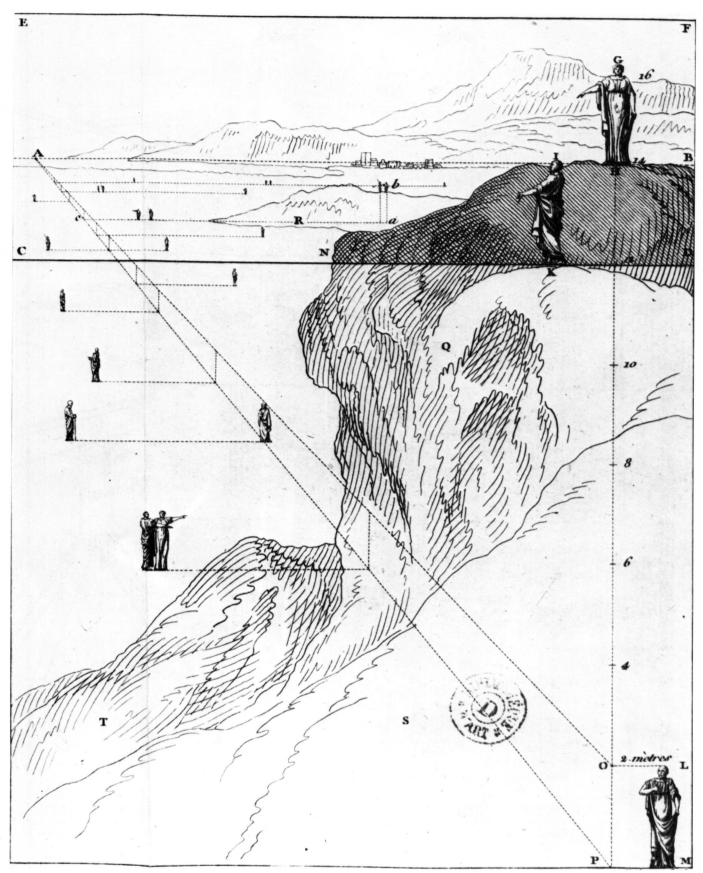

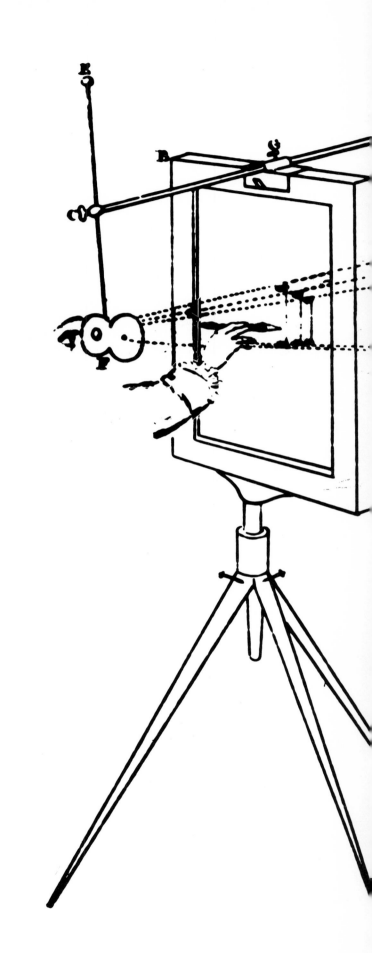

19TH CENTURY

Jean-Thomas Thibault (1757-1826). Painter, architect. Born in Montier-en-Der (Haute Marne), studied in Paris. Superintended the decoration of the residence of the Prince de Conti at l'Isle-Adam. Studied under and worked with Étienne-Louis Boullée (1728–1799). Traveled to Rome. Worked for the Queen of Naples at the Elysée Palace and at Neuilly, and also on the gardens of Malmaison. Followed Louis Bonaparte to Holland, where he restored, among other buildings, the palace at Amsterdam and the castle at Loo. He returned to France in 1809. Member of fourteen institutes, professor of perspective at the Ecole Royale des Beaux-Arts.

Application de la perspective linéaire aux arts du dessin, a posthumous work, published in Paris in 1827 by Thibault's student N. Chapuis.

Plate 149: Faulty perspective and corrected perspective.

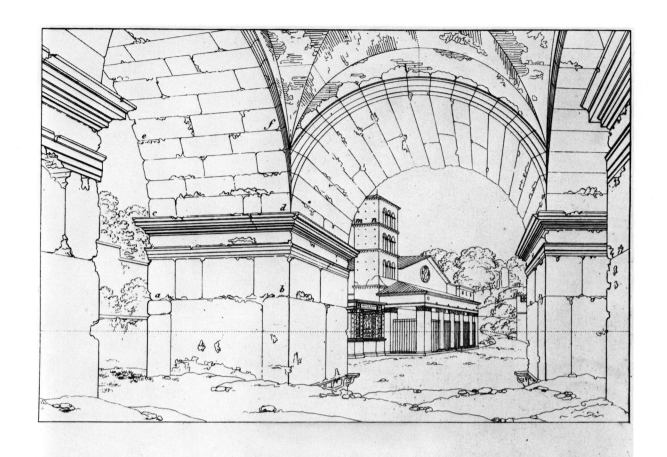

Fig. 1. Fig. 8. Fig. 2. Fig. 9. Fig. 3. Fig. 10. Fig. 4. Fig. 5. Fig. 7. Fig. 6.

150

Adèle Le Breton, married name Jarry de Mancy (b. 1794). Studied with her father, J.-F. Le Breton (painter, professor of perspective and design at the Institut des Sourds-Muets (Institute for Deaf-Mutes). Author of *Le Dessin d'après nature et sans maître* (1830).

Traité de perspective simplifiée (linéaire) dédié à son Altesse Royale Mademoiselle, par Madame Adèle Le Breton, née Le Breton, peintre et professeur de perspective, élève de son père. Paris, chez l'auteur, rue du Pot-de-Fer, no 20, Paris, 1828. Engravings by Hocquart Jeune.

In the preface, Le Breton links perspective and perspicacity. "My father's approach is not to divorce drawing from perspective." She refers to Jean-Jacques Rousseau's research in order to explain how perspective operates: After undergoing an operation for cataracts, "a person blind since birth at first thought everything he saw was touching his eye. He then realized his mistake by stretching out his arm. This was his first experience of perception in perspective." She also recounts an interesting anecdote. "During the Reign of Terror, my father gave lessons to Mme. Helvétius while she was in prison. When his student had finished sketching everything in sight, a model was needed. The guard posed for her."

Plate 150: Perspective and fashion; or the transformation of Piero della Francesca's *torculo*, or neckpiece in perspective, into collars.

Plate 151: Perspective in mirrors.

Plate 152: Equipment needed to set up a panorama. The first diorama was invented in 1823 by Louis Daguerre and Charles-Marie Bouton (1781-1853).

Plate 153: Anamorphic designs: a hidden image; the letter A transformed into snakes.

Fig. 2

Fig. 1.ᵉʳᵉ

Fig. 3.

Fig. 4.

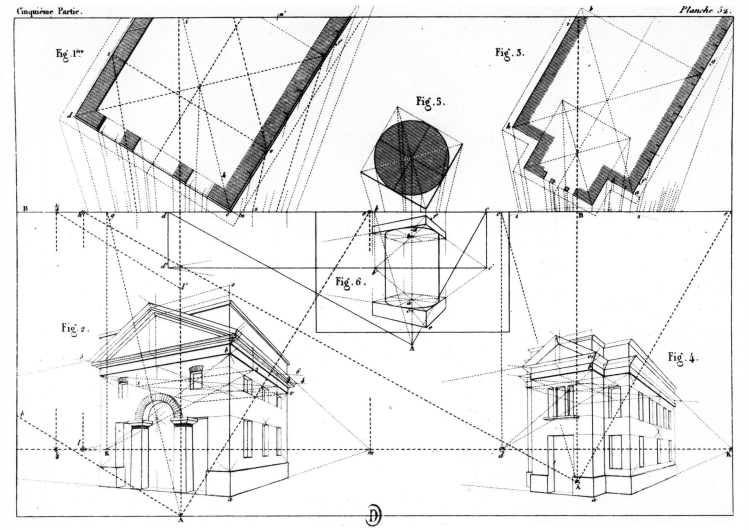

Fig. 1ère.

Fig. 3.

Fig. 5.

Fig. 6.

Fig. 2.

Fig. 4.

154

Charles Pierre Joseph Normand (1765-1840). Architect and engraver. Awarded the Prix de Rome in architecture in 1792. His engravings were used to illustrate such works as Charles-Paul Landon's *Les Annales du musée* and *Les Vies et oeuvres des peintres;* Charles Clarac's *Le Musée de sculpture;* Alexandre Lenoir's *Le Musée des monuments français;* and Percier and Fontaine's *Le Recueil de décorations intérieures.* He wrote *Nouveau parallèle des ordres d'architecture des Grecs, des Romains, et des auteurs modernes* (1819), *Vignole des ouvriers* (1821–35), *Guide de l'ornemaniste* (1826), and *Vignole des architectes* (1827–28).

Parallèle de diverses méthodes du dessin de la perspective d'après les auteurs anciens et modernes. Ce parallèle élémentaire et pratique est divisé en 9 parties. Chacune des parties est enseignée par une méthode différente et, par leur rapprochement, on voit que, dérivant du même principe géométrique, elles donnent toutes le même résultat. Cette diversité de méthodes intéressante et instructive est applicable à l'enseignement de cette science dans toutes les écoles où l'on professe l'art du dessin, par Charles Normand, architecte, ancien pensionnaire de l'Académie de France à Rome, Paris, 1833. The following sources are cited in the frontispiece: Sebastiano Serlio, Dürer, Pozzo, Sébastien Leclerc, Jeaurat, Valenciennes, and Thibault. The *Parallèle* depicts ancient cities that may have also been drawn by Claude-Nicolas Ledoux (1736–1806).

Plate 154: Plan and perspective view of two pavilions and a cylinder.

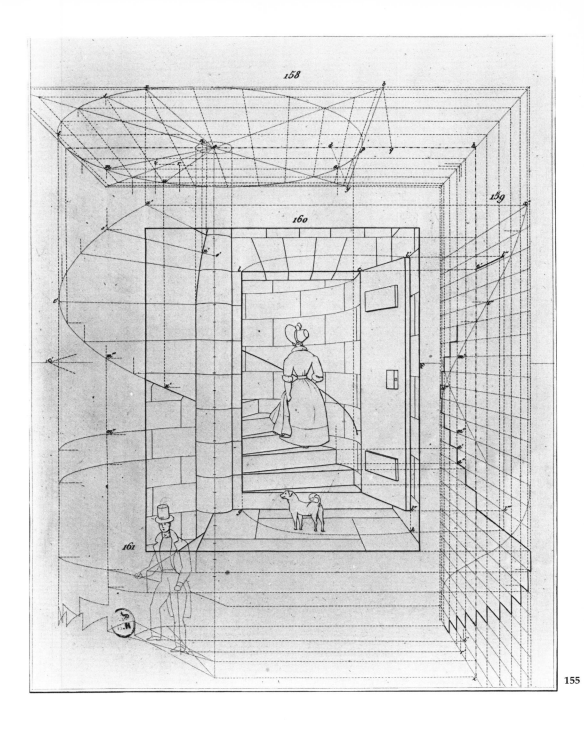

Joseph-Alphonse Adhémar (1797-1862). Mathematician, born and deceased in Paris. He was the first to propose a railway encircling Paris. Author of *Cours de mathématiques à l'usage de l'ingénieur civil* (1832); *Traité de perspective linéaire* (1838); *Traité des ombres* (1840); *Révolutions de la mer* (1842); *Nouvelles Etudes de coupe de pierre* (1856); *Nouvelles Etudes de charpente* (1858); *Beaux-arts et artistes* (1861). These volumes were all published in Paris.

Traité de perspective à l'usage des artistes, Paris, 1836.

Second edition: 1846. Third edition: 1859.

Clashed with Etienne Delécluze, for whom scientific perspective was "antipictorial." Adhémar sought to reunite the artist and the geometer and lamented the fact that the artist Jacques-Louis David was incapable of reading an architectural drawing. "When teachers express themselves thus, it is hardly surprising that students should have such an aversion for studies in geometry."

Plate 155: Staircase.

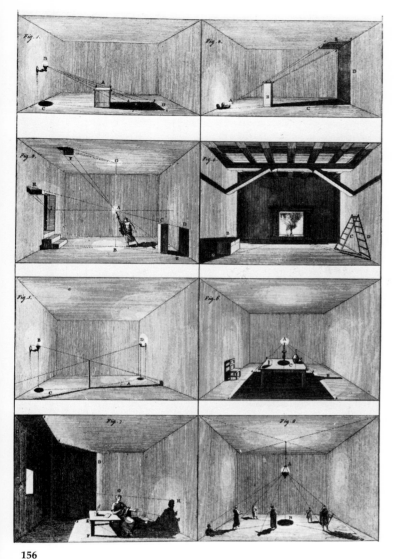

156

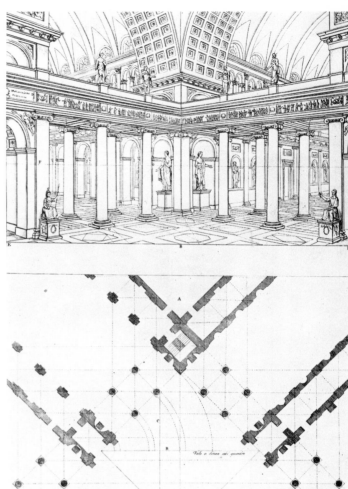

157

Giacomo Fontana (1805-1880). Architect, perspectivist, and engraver.

La prospettiva dimostrata con regole pratiche dall'architetto-prospettico ed incisore Giacomo Fontana. Opera divisa in quatro parti con cento venti tavole in rame in due volumi, Roma...presso l'autore, Rome, 1851.

Fontana's work recommends the techniques and equipment of the sixteenth and seventeenth centuries. It was evidently intended for stage designers in particular: it shows how to apply perspective in both the construction of scenery (Egyptian, Turkish, Byzantine, Persian, and Gothic) and the reconstruction of ancient cities.

Plate 156: "On shadows at night."

Plate 157: Perspective view of an interior architectural angle.

Plate 158: On designing perspectives with a glass or transparent screen.

Plate 159: "Shadow effects in houses."

Plate 160: Two Turkish scenes.

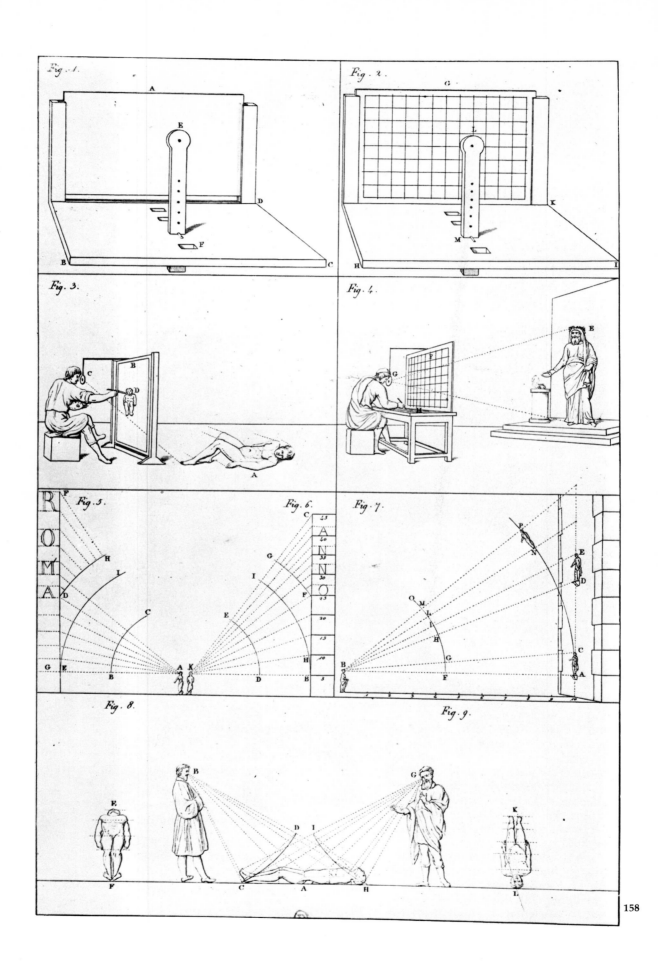

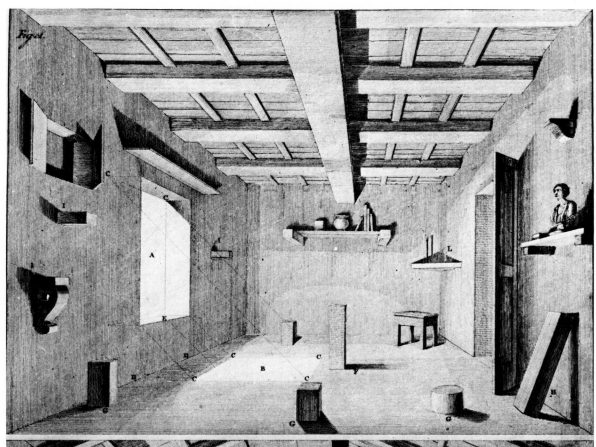

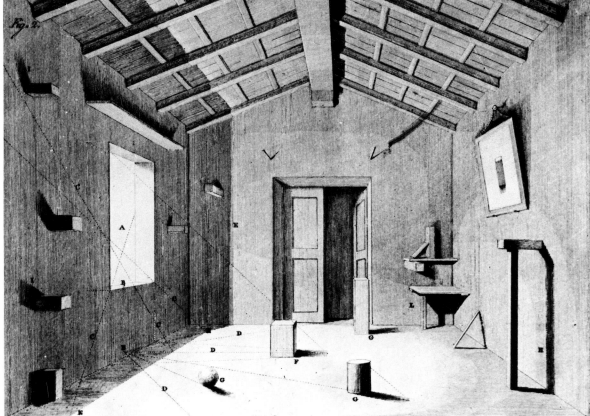

159

160

PHOTOGRAPH CREDITS

Bibliothèque Nationale, Paris: Plates 1, 12, 13, 14, 15, 16, 17, 18, 19, 21, 22, 23, 24, 26, 27, 28, 29, 33, 34, 35, 36, 53, 54, 55, 56, 57, 118, 119, 129, 149, 155. Collection Viollet, Paris: Plate 2. Claude Parent, architect: Plate 5. Albert Flocon (original engraving): Plate 4. The remaining illustrations are photographs taken of works in the collection of the Bibliothèque de l'Institut d'Art et d'Archéologie (fondation J. Doucet).